True Tales
OF
PUGET SOUND

To
(Lenis,) just a moment — I
misheard ♡

Olivia, Fiona, and Eliza —

So you can appreciate
the history of where you
were born —

Harriet Wilber

True Tales

OF

PUGET SOUND

DOROTHY WILHELM

FOREWORD BY DAVE ROSS, BROADCASTER AND COMMENTATOR

THE
History
PRESS

Published by The History Press
Charleston, SC
www.historypress.com

Front cover, top: *Moorage at Sunset, Puget Sound, Washington*. Steilacoom glows in melting colors that are surely too good to be true, which is a normal day on Puget Sound, whether the sun shines or not; *front cover, bottom*: *That Old Gang of Mine*. Milton in the 1930s, when a mule named Boston Curtis made his hoof mark on the papers and ran for the office of committeeman. These hardy residents must be eagerly awaiting the results.
Back cover, bottom: Puget Sound and Mount Rainier frame everyday life. There are still South Sounders who call that snowy peak Mount Tahoma, or Tacoma, because Rainier was British—an outsider in a country of mavericks; *inset*: *First Things First*. Beloved cowboy artist Fred Oldfield shows a light—a metaphorical welcome to all who came from all over the world to make the Puget Sound country their own.

First published 2019

Manufactured in the United States

ISBN 9781467139694

Library of Congress Control Number: 2018959003

Notice: The information in this book is true and complete to the best of our knowledge. It is offered without guarantee on the part of the author or The History Press. The author and The History Press disclaim all liability in connection with the use of this book.

DEDICATION

*J*OAN K. MARSHALL was the third of five generations in her family to serve in tribal leadership for the Steilacoom Indian Tribe. She faithfully served from 1975 until illness required her retirement, just before passing on from this world in 2006. Overseeing the development of the Steilacoom Tribal Cultural Center in the historic district of Steilacoom was just one of her many accomplishments.

It was from Joan that I first heard the story of the People of the Pink Flower.

SPECIAL DEDICATIONS

FATHER FRED MAYOVSKY, SJ
Who kept saying, "Why don't you write something new?" Nothing can be more new than history.

ED HAUGE and the *My Home Town* crew
Without you, this book could never have happened

Finally,
To my six kids, and all their families, the grandchildren and the great-grands. Without you, I'd never even have started this. We all love stories of the beginnings.

CONTENTS

Foreword, by Dave Ross 9
Acknowledgements 11
Introduction 13

Part I: THERE GOES THE NEIGHBORHOOD
1. Fort Nisqually: Why Did It Go? 17
2. Tumwater: The Oregon Trail Ends Right Here—And
 Here—And Over There 35
3. Olympia: John Wayne Didn't Settle the Territory,
 Neither Did Julia Child 51
4. Bonney Lake: The Longmire Journey? That Was No Party. 58
5. Spanaway: Mrs. Mahon's Tablecloth 66
6. Old Fort Steilacoom: The Little Church that Could
 (And Still Can!) 77

Part II: THE TERRITORY GROWS
7. Orting: Reclaiming the Dark Tower 91
8. Parkland: Give Us a Vote and We Will Cook 98
9. University Place and Fircrest: A Short Tale of Two Cities 106
10. Milton: The Mule that Ran for Office—And Won 113
11. Eatonville: Painting the Town Red 121
12. Buckley: The Great Wine and Swine Wreck 133

Part III: HEART AND SOUL
13. Steilacoom: The Ghost in the Mansion 141
14. Tacoma: Arm in Arm in Arm—Octopus Wrestling
 under the Bridge 149
15. Gig Harbor: The House that Nellie Built 158
16. Lakewood: Barbie and Ken and Kalvin 163
17. Enumclaw: The Pie Goddess Had a Secret 170
18. Puyallup: Set the Prairie Afire 174
19. Fox Island: The Legend of the Clay Babies 182
20. Fife: Return from Minidoka 188
21. Final Word: The Heart Lady of Fox Island 198

Bibliography 201
About the Author 205

FOREWORD

*I*n an age when everything we read is suspect, Dorothy Wilhelm wants you to know we need to fact-check the past as well as the present.

In this collection, she ruthlessly wrestles to the ground some of the Northwest's more persistent legends to find out what really spawned them and who these people really were.

Back in the days when social media was face to face, the user agreements were about the same as they are now—whoever you shared your story with had the right to retell it endlessly. Then as now, there was always a much larger audience for the embellished version.

And given the eclectic mix of adventurers, warriors, hunters, fortune-seekers, ex-slaves and nomads who followed the Oregon Trail to the end, we've inherited some pretty memorable embellishments.

The real stories may not be as tidy as the legends they spawned, but then reality never is.

And so, summoning her inner Tomb Raider, Dorothy has tackled the following historical riddles:

—Why a middle school teacher incorporated a dead pig into his Oregon Trail curriculum

—Whether the Longmire Party really did kill their oxen and braid the hides so they could drop them safely down the mountain

—Who is Elizabeth Mahon, why is her tablecloth so famous and how did she end up buried on a golf course?

—How the women of Parkland used a cookbook to win back the right to vote

—Why University Place near Tacoma has no university

—Why Fox Island has no foxes but *does* have Clay Babies

—Did the people of Milton really elect a mule named Boston Curtis as mayor? And how did he get along with the city council?

—Is it true that the expression "paint the town red" originated in Eatonville, due to the high copper content in the Mashel River, which allowed the manufacture of the most durable red paint ever invented?

—What happens when a train carrying a shipment of wine collides with a train carrying a shipment of swine (besides the best local headline ever)

—Is the E.R. Rogers mansion in Steilacoom really haunted, and if not, why was E.R's favorite rocking chair suddenly appearing in front of the window overlooking the Sound?

—Whatever happened to Gig Harbor's famous Nellie the Pig, who once appeared on every TV show from Carson to Leno and even had her own canopied bed in a house built with her earnings?

—Whatever happened to life-size mannequins Barbie and Ken that for years sat together outside a Lakewood business, got married and had a mannequin child?

—And for those of you who've ever had a Pie Goddess pie in Enumclaw, can Dorothy persuade her to reveal the long-rumored secret ingredient that makes the crust impossible to copy?

All of these are questions I never even thought to ask, much less fact-check. And it's why this volume was urgently needed. I, for one, hope it inspires a new generation of quirky Northwest characters.

This is where the trail ended—where restless people who didn't fit in anywhere else finally ran out of continent. But the farther we get from the pioneers who provided the raw material for these stories, the more we risk becoming—dare I say it—ordinary. And that will not do for a land of glaciers, volcanoes, earthquakes, billionaires and salmon willing to die for sex.

This book reminds us that no one is going to remember a bunch of people who spent their social lives swapping emojis. But they will never forget your pie crust.

—Dave Ross, radio host and commentator
Edward R. Murrow Award Winner 2018

ACKNOWLEDGEMENTS

*H*istory doesn't stand still. New history was being made as we finished our first cup of coffee in the morning, and of course, it goes back farther than we can trace. We couldn't write about it if many people didn't generously share the information they have about the shaping of this country and the passions they share. What's amazing is how many folks are willing to share the pearls they've discovered.

Anyone who knows me knows I am not a historian. I'm a storyteller, definitely, a folklorist, maybe, but I couldn't begin to talk about history without help from those who have spent huge chunks of their lives researching it.

It won't be possible to mention everyone, but let me give it a try:

Thanks first to Karen Meador, who started me off on this journey with her great project on the Old Military Road.

Thanks to Living History tribute performer Ray Egan for his shared insights into the life of Father Rossi and old Steilacoom.

To Drew Crooks, distinguished historian, who has a special interest in the story of Fort Nisqually and DuPont. Drew was kind enough to point out errors and omissions, and if there are any missed, they are definitely mine, not his.

Thanks to Robert Cooksey, who has taught generations to live and love history.

To Don Trosper and the Olympia Tumwater Foundation for proving that history is most alive when it's relative and to Karen Johnson, who was the

first to point out to me that I am a folklorist and that there's no reason the truth can't be entertaining.

Special thanks to Dave Ross, who is just as kind and just as prescient today as when we occasionally shared a microphone at KIRO back in the '90s. He's added a lot of Edward R. Murrow Awards since then, two more in October 2018. The man is unstoppable.

Thanks to Ben Sclair, editor, publisher and wizard behind the *Suburban Times* (SuburbanTimes.com) for kindly giving permission to quote extensively from stories published first in the *Times*, especially "In Tracing the Historical Connection between University Place and Fircrest," by Blake Surina.

Thanks to Allan Stein at History Link (HistoryLink.org) for sharing the many excellent resources by historians we might never meet otherwise.

Thanks to Jean Sensel, author of *Spanaway*, who has been unfailingly generous with her information. She filled in many of the blanks for me.

To Elsie Yotsuuye Taniguchi, who helped me understand the terrible era of the Japanese internment and why it must never happen again.

To David A. Takami for telling me more of the Divided Destiny of our Japanese American citizens.

Thanks to Sally Everding for keeping my prose on track at a very difficult time.

Thanks to DuPont Historical Society, Lakewood Historical Society, Steilacoom Historical Museum Association, Historical Fort Steilacoom, Steilacoom Tribal Cultural Center, Greater Bonney Lake Historical Society, Prairie House Museum & Spanaway Historical Society and all the historical societies that helped out, reenactor Synthia Santos, Pat and Edwinna Van Eaton, Louanne Taylor, Ron Keough and Joan Simons Ranch, Joan Curtis, Lenore Rogers, Barb Kohler and especially Claire Keller-Scholz at Point Defiance Living History Museum and Metro Parks, Tacoma. Claire, with her great staff and volunteers, gave me so much help, while pretending not to notice the chip on my shoulder about the present site of Fort Nisqually. She is directly responsible for my ownership of one of the very few Dr. William Fraser Tolmie teddy bears in the Puget Sound area.

Finally, let me acknowledge my assistant, Gina Wilhelm. She is a professional puppeteer, but I've kept her hands full.

I said I probably couldn't remember everyone, and I was right. But to everyone who helped with this project, and there are so many, you know who you are, and so do I. These stories belong to all of us. Thank you.

INTRODUCTION

A myth is a story that is true—whether it really happened or not…
—Dr. Chris Wilhelm

I didn't learn one thing in my Washington State history class. Although it was required for all students in my freshman year of 1948, I came away with the conviction that Washington State must be so new or so dull that it hadn't any history at all worth talking about. Then, about fifteen years ago, I began to host and produce a TV program called *My Home Town*. Over the course of a decade with the show, we were on location with our TV crew in more than one hundred Puget Sound towns. We focused on what's going right in each of these communities. I was heartened and encouraged to learn that plenty is going right in our small towns, no matter what you hear on the evening news. Each show included at least one history segment. But the biggest surprise was that each community we visited was rich with history, and—even better—each town had a collection of unique stories of its own, illustrating the unique nature of that town.

Best of all, everywhere we went, inevitably, someone would grab me and pull me aside saying, "Listen, you've got to hear this story. You've never heard this one before." And sure enough, I never had. Those are the stories in this book. There are stories of Native American legends, stories of communities that pulled together in hard times, stories like the tale of Boston Curtis, the mule that ran for office and won.

Of course, these are just a small sampling of the wonderful stories of Washington from territory to today. The reader is almost sure to say, while

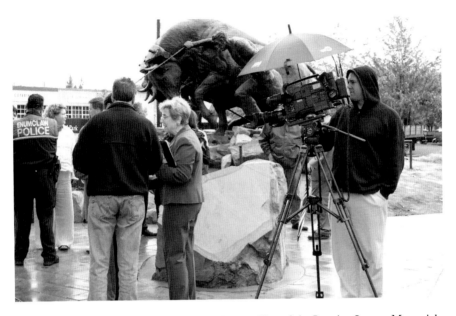

My Home Town host and crew on location at the unveiling of the Logging Legacy Memorial in Enumclaw. *Author's collection.*

struggling home with an armful of books for gifts, "This is all very well, but I can't believe Dorothy didn't include the Pig War, or Job Carr's story, and where is Ezra Meeker?"

It's true these luminaries are among the missing—although Ezra does make a cameo appearance. It's not because they aren't important but because when I went back to review these stories, I found that what I had to tell was the rest of the story. These are stories of events from twenty different Puget Sound communities, and if you take the kids and go to one of them this weekend, you'll be able to find out what happened after the lights went off and the TV crew went home. I came to understand the most important thing—that these were real people who lived and struggled, not just figures put on a page so Miss Hepplewhite would have something to test her classes on.

So here are the stories I was told. Some of them are different than the original version, and I tried to put that in, too. These are stories and folklore, memories and adventures, all carefully researched with the help of local historians with notes to tell you how to find more of their work. Here are some stories I liked, and I think you'll like them too. There are more where they came from.

Dorothy Wilhelm

14

PART I

There Goes the Neighborhood

1

FORT NISQUALLY: WHY DID IT GO?

THE STORY THEY TELL

There's no fort in DuPont. Let me make that clear from the start. A fence encloses the area where Fort Nisqually once stood. But the buildings are gone. There's just an outline made with logs that shows the placement of the old fort. And a line of locust trees planted in the 1850s. And grass. Lots of very tall grass.

My evening walk takes me right past the historic spot where Fort Nisqually was built in 1843 near Puget Sound in what became Washington Territory. If I turn the other way and walk along the Sequalitchew Creek Trail, it's easy to look down to the shore and back in time to 1832 to imagine the men who built the rough cabin that would become the first trading post on that same spot. It's always good for a half cup of coffee at the Starbucks up on Center Drive to speculate on how the early residents of DuPont could have been so foolish and short-sighted as to just stand there while this arguably most important historic building in the territory was removed and carted away by strangers.

The story is often told that the people of DuPont looked at the old fort and saw only a pile of rotting wood that had outlived its usefulness. They missed the historical value and let it get away. They say. But it wasn't that way at all.

HERE'S THE REST OF THE STORY

Fact-checked: Like most good stories, this one is about half-true—the good half. Today, fully restored and actively used by the community that adopted it, Old Fort Nisqually stands on a lofty bluff in the sprawling Point Defiance Park in Tacoma, Washington. Studded with ancient fir trees just right for hugging, this part of the 760-acre park has changed little since George Vancouver sailed into Puget Sound in 1792. By car, it is twenty-two miles, twenty-eight minutes and a lifetime away from DuPont, where Fort Nisqually was erected in 1843.

It's easy to forget that the men who built the first permanent non-native settlement in America, the founding Hudson's Bay Company (HBC), were British. Weren't we mad at them? A force to be reckoned with from the beginning, the Hudson's Bay Company, chartered May 2, 1670, is the oldest incorporated joint-stock merchandising company in the English-speaking world. It continues strong even today, so the HBC interest in the New World was something that couldn't be ignored.

By the time the Hudson's Bay Company came to the Puget Sound country, the HBC had already made incredibly successful inroads through

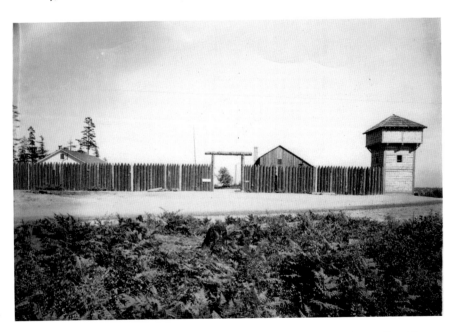

Fort Nisqually entrance and watch tower in present location at Point Defiance. *State Library Photograph Collection, 1851–1990, Washington State Archives, Digital Archives.*

Fort Nisqually print, 1843. *Library of Congress, Prints & Photographs Division.*

North America (including the Pacific Northwest). Now the company that writer David Lavender called "The Fist in the Wilderness" had to choose a point from which to support trade between Fort Nisqually and Fort Vancouver. It should have been an easy decision because after a rough start, the Hudson's Bay Company was a model of economy. Chief Factor John McLoughlin administered thirty-four outposts, six ships, twenty-four ports and perhaps eight hundred employees. The HBC was not interested in bringing settlers or establishing communities in the new country; in fact, it actively discouraged them. They were good men of business looking to make a profit from what were arguably the most beautiful furs in the world. They would succeed beyond their wildest dreams.

In 1832, the Hudson's Bay Company's Chief Trader Archibald McDonald was sent north from Fort Vancouver to establish that very important post on Puget Sound. Murray Morgan, in his book *Puget's Sound*, wrote, "He picked the hill rising above the North Shore. There is a clear, unparalleled vista of cliff and water." There, as Morgan reported, "his party knocked together a rude storehouse, 20 feet by 15, with a dirt floor, log walls, cedar boards for roofing." Honey, they're home! Nisqually House was born.

It wasn't exactly a party. In the fall of 1832, it was William Ouverie and "two other hands" who were left behind to do the work. The record also

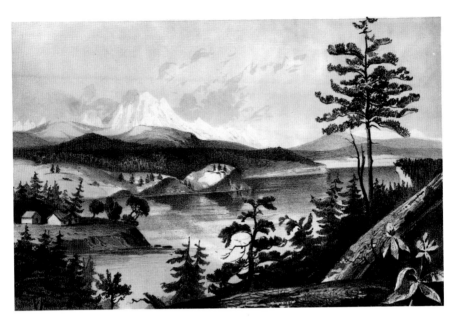

Early Washington Territory, Mount Baker from Whidbey Island. *State Library Photograph Collection, 1851–1990, Washington State Archives, Digital Archives.*

states that they had a "keg of nails, a bag of potatoes, a bag of flour" and some beads and trinkets for barter. There was a heavy rain most of the time, Ouverie journaled. He shouldn't have been surprised. Drew Crooks points out that Ouverie had been in the Northwest since 1813 and so had a pretty good idea of what to expect from the elements.

Unexplored and undeveloped, the area near Sequalitchew Creek area could supply valuable animal pelts, so that was the place to start. The fledgling traders had their hands full. Edward Huggins, who later became the manager of the fort, reported in the *Journal of Occurrences*:

> *People have been put on various little jobs about the place—the principal one is the building of a small house on the edge of the plain above the high bank which lines the whole of these shores and must be at least half a mile from the Trading house and Naval depot below—a farm house on the site I speak of is indispensable on account of the live Stock and many other considerations.*

It's easy to create a romantic mental picture of those first trappers, singing soulful folk tunes, sort of like Pete Seeger with a strong French Canadian

accent, as they knocked together a couple of shelters. It definitely seemed reasonable that between songs and checking their trap lines they would cook up a stew of the varmints that they came to trap and of course fish from the nearby waters. This was not a correct picture. Inhabitants of the fort did not have to munch on critters. There was beef. Over two thousand head of longhorn cattle were herded up from Texas and Mexico, and other livestock soon began coming in on the *Beaver*, built for the HBC in London in 1835. *Beaver* was the first steamship to reach the Puget Sound. With the advent of easy steamship travel, the area was ready to put down roots and grow. The Hudson's Bay Company didn't like that idea at all.

It was true that HBC coveted the lush furs that came from the new territory and had no plans to encourage or even allow settlers to come in and spoil the trade and the profits. The company did not hold visions of thriving communities of farmers and bustling shops. If the HBC had its way, the Puget Sound area would stay exactly as it was, but the determination of the settlers couldn't be ignored. Better to make the best of it, the company decided. A change of plans was called for, so HBC

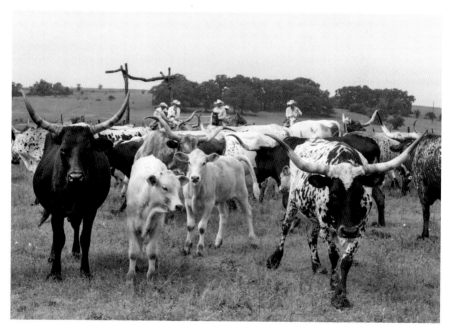

Longhorn cattle drive. Little has changed with these tough cattle since the drives to Fort Nisqually. *Library of Congress, Prints & Photographs Division, photograph by Carol M. Highsmith.*

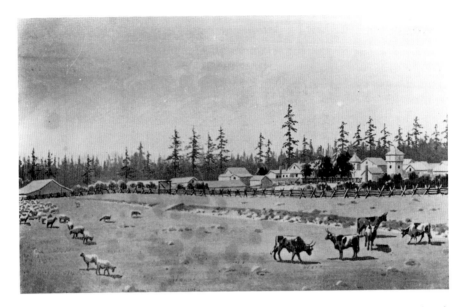

Early drawing of Fort Nisqually. The sheep and cattle suggest the Puget Sound Agricultural Company days. *University of Washington Libraries, Special Collections, NA4132.*

created the Puget Sound Agricultural Company in 1838 to take advantage of the agricultural opportunities the inevitable flow of settlers was bringing to the Pacific Northwest. This new company ensured that when travelers and settlers needed to buy supplies for their new ventures, the Puget Sound Agricultural Company would be the only place those supplies were available. That meant that the Hudson's Bay Company would still set the prices. And it did.

The fort was established and manned by an astonishingly diverse group of workers, including Native American people like the local Nisqually and Steilacoom and the Iroquois Indians who had migrated west. There also were French Canadian voyageurs, Orkney Islanders and Hawaiians, who played a big part in the development of the fort. They were recruited in their own lands by the captains of ships that made their way to the Columbia River. People from the local tribes were recruited as hunters and interpreters. They cared for the horses. They were trappers. They were guides—for after all, they knew the area better than anyone else possibly could. This diverse group worked together to make history. On the eighth Saturday of 1833, the first historical record of a visit by Chief Chihalucum (Steilacoom) to the fort was registered in the *Journal of Occurrences*. It was thought that the name of the tribe came from this dignified headman, but

in fact, the tribe's name, Steilacoom, is a geographic reference to the place they were from, according to tribal elder Danny Marshall, so it would be "people from where the pink flower grows," so named for the ground cover of pink flowers that grew everywhere.

THE SETTLERS WERE ON the way, and they were coming by the thousands. The trek began in earnest in 1853, when the John Longmire party completed the incredibly difficult journey over the Naches Pass Trail, which brought some of the bravest of the newcomers who had come to stay.

Dr. Tolmie went out from Fort Nisqually to assuage the hunger of the travelers by bringing them a wagonload of beef and supplies. As the travelers arrived in the Puget Sound country after that grueling journey, they were dismayed to find that the Hudson's Bay Company did not want them there and was prepared to go to great lengths to discourage them from settling. Settlers and community building was the last thing on the HBC's to-do list. But the newcomers were determined to make a new life in this new land no matter what. The trading post continued to see brisk traffic in the incomparable furs. Even at that early date, they supplied the famous Hudson Bay blankets, with their distinctive line markings. Those blankets provided warmth on the coldest winter nights and were turned into practical, nearly indestructible coats and capotes by trappers and traders. Standard pay to a trapper for one first-class fur was a three-line blanket, according to the *Fort Nisqually Indian Account Book*. By 1841, the fort was selling beef, butter and cheese to the Russians who had settled in Alaska and found their way to the Northwest.

The year of the Great Migration, 1853, brought one thousand settlers to the Oregon Territory. Today, one thousand new residents move to Seattle each week.

The original 1833 location of Fort Nisqually was on what is now the Home Course golf course in DuPont. This first location was easily accessible by the water for shipments from trappers who brought in their pelts by water, secluded and welcoming. However, it was a low site, surrounded by rolling hills with poor visibility if safety should become a consideration. There needed to be a new, more accessible site for Fort Nisqually. Where the first fort was low, near the water, the second site must sit higher and have good visibility. In 1843, the station was moved closer to Edmonds Marsh and Sequalitchew Creek, a beautiful, clean, freshwater source, with plenty of timber for building, fuel and commerce. Fort Nisqually started to import livestock and crops for local

consumption and export principally to Russian Alaska, the Kingdom of Hawaii and Alta California, according to historian Drew Crooks.

The site of the second Fort Nisqually, now popularly called the 1843 Fort, is easily accessible today on Center Drive, which is, as the name implies, the main road through DuPont. It's easy to step out of your car and walk around the perimeter of the grounds, admiring the orchard and visualizing the settlers walking out to fill water buckets in the creek, which ran faster in those days than it does today. It's impossible not to be inspired by what is arguably the most gorgeous view of Mount Rainier in three counties. At the edge of the creek, you might spot a translucent brown salamander sunning himself where his ancestors did the same thing.

As more and more immigrants reached the Pacific Northwest, it became apparent that the Hudson's Bay Company had created what was in effect a company store, rivaling today's Amazon in breadth and variety. There was, as David Lavender observed in his book about HBC, *Fist in the Wilderness*, "No place [for trapper or farmer] to sell his wheat or furs except the company warehouse, no place to buy goods except at the company store. He could not even repair a broken tool without taking it to the company store."

In fact, the success of the monopoly was so great that the Hudson's Bay Company became the de facto government of the Northwest. Dr. John McLoughlin's method for assuring that things went well was by imposing military discipline. McLoughlin managed the area from Fort Vancouver and has been called the most important European in the Northwest.

An agent for the U.S. government (and strong believer in Manifest Destiny) who visited, as recorded in *The Canadian Encyclopedia*, declared, "Some steps must be taken by our government to protect the settlers and traders not from the hostility of the Indians, but from a much more formidable enemy…The Hudson's Bay Company."

The traders and the native people continued to make their way through these new situations—the HBC continued to be dead serious about making a profit for HBC, and life had to go on. But soon someone would arrive to provide the leadership that was lacking.

Dr. William Fraser Tolmie arrived at Fort Nisqually on May 8, 1843. "He was a slight, serious young man of twenty-one, smelling strongly of skunk," Murray Morgan reported in *Puget's Sound*. "The good doctor, a naturalist, born in Inverness, had been fascinated by one of those graceful animals and tried to get a closer view. He succeeded," Morgan observed.

Dr. Tolmie made a lasting impression. Murray Morgan also wrote that Dr. Tolmie was the first tourist to climb Mount Rainier. Historian Drew Crooks

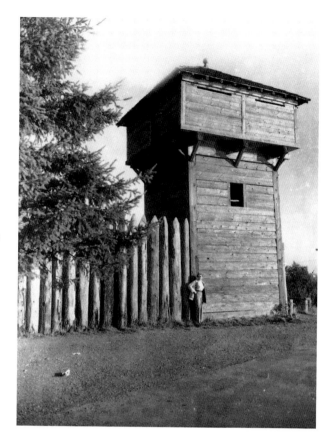

Right: Pop quiz: Was this picture taken before or after the fort moved from DuPont? Fort Nisqually Watchtower, circa 1950–70. *State Library Photograph Collection, 1851–1990, Washington State Archives.*

Below: Fort Nisqually watchtower, 1884. *State Library Photograph Collection, 1851–1990, Washington State Archives, Digital Archives.*

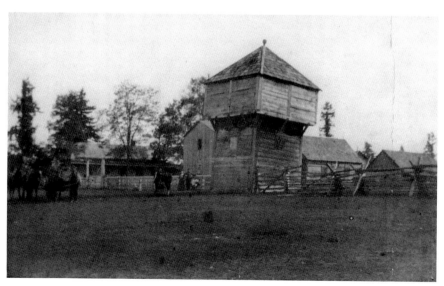

pointed out that Dr. Tolmie did not reach the summit. The first successful climb by Euro-Asians was in 1870. (As the mother of six, the author feels compelled to add, "Well, at least Dr. Tolmie tried.") Tolmie was the heart of the fort until he moved to Victoria on Vancouver Island in 1859.

Tolmie was the manager of the Puget Sound Agricultural Company from 1843 to 1857, overseeing the pastoral and agricultural projects from Fort Nisqually. His tenure covered the transition from British to American control beginning in 1846 as result of the Oregon Treaty and the Puget Sound War. He was well respected because of his experience with the region and maintained friendly relations with the British, indigenous peoples and American settlers.

The 1843 location of the fort in DuPont, where the buildings now at Point Defiance were originally located, is owned by the Archaeological Conservancy and managed by DuPont Historical Society. The only visible remnants of the original fort are a line of black locust trees, planted in the 1850s.

The Treaty of 1846 protected the rights of the Hudson's Bay Company and Puget Sound Agricultural Company until they were purchased by the U.S. government. As with so many lodestones of western development, the time of the HBC and PSAC at the second Fort Nisqually was brief—only a little more than twenty-five years from beginning to end. Then, in 1869, the U.S. government finally purchased the two British companies' rights in the region. Fort Nisqually was closed in 1870. Drew Cooks adds:

> *By the early 1930s, the buildings of Fort Nisqually had fallen into terrible disrepair. They were the first and the oldest structures in the area and remain the last original Hudson's Bay Company Buildings in the United States. They had both sentimental and historic value. What could be done to save them? Here is where the story differs from the one that's commonly told. The residents of the village now called DuPont weren't indifferent to the fate of the old fort. When Dr. Tolmie was ordered to Fort Victoria in 1859, Edward Huggins was placed in charge of Fort Nisqually. In June 1870, the Puget Sound Agricultural Company surrendered the rights to the fort and land in accordance with the Treaty of 1846. Huggins was ordered to the interior of British Columbia. He believed that the Agricultural Company was not truly affiliated with the Hudson's Bay Company and didn't want to leave the land he'd come to belong to. Huggins resigned and became a citizen of the United States. He bought the portion of the land on which the buildings stood and began to farm it. Later, he was able to buy the rest of the land as well as about one thousand acres from the Northern Pacific Railroad.*

The DuPont de Nemours and Company bought the land from Huggins. "Edward Huggins, a clerk, took over the site at Nisqually which he sold to the DuPont Powder Company," historian Clarence Bagley wrote. So DuPont now owned the town of DuPont, all the houses and all the land, including the old fort. The company respected the significance of Fort Nisqually, even putting up a historical marker on the site.

It turns out that Mr. Huggins wasn't just enjoying a gentleman farmer's retirement. He conducted what today would be called a media blitz and made himself responsible for getting the word out about these emblems of the "first and early" presence of the Hudson's Bay Company. Before he sold the site to the DuPont Company, Huggins invited media folks to the site of Fort Nisqually and made very sure the importance of this historical site was well known. However, as time goes by, memories dim, so between 1907 and 1933, the historical slipped away from the practical, so whatever urgency there had been about saving the site and the buildings was lost.

At that time, the Tacoma Chamber of Commerce expressed interest in restoring the two remaining buildings at Fort Nisqually—the granary and the factor's house—and to replicate the other buildings, which had fallen to ruin. Tacoma was the nearest large town with civic resources that might be able to undertake historic preservation of this magnitude but, according to curator Bill Rhind, at that point, there was no thought of moving the buildings anywhere else.

This was the time of the Great Depression, and the Civilian Conservation Corps (CCC) was looking for projects that would provide employment and aid and put people back to work. One project that was undertaken was to clear-cut wood from the standing forest at Point Defiance Park in Tacoma. The wood was given to the poor, and where the woods had been, there was a beautiful space overlooking Puget Sound just calling out for something spectacular to fill it. It was decided to move the remaining Fort Nisqually buildings the twenty-four miles from DuPont to the spectacular bluff above Puget Sound, where it fits as if it were designed for it. Bill Rhind wrote in the *Curator's Journal of the Fort Nisqually Living History Museum* that although many people worked on this project, the Young Men's Business Club of Tacoma deserves the credit for being the driving force and getting the work done. The CCC also did much of the work. When the grand opening of Old Fort Nisqually in its new location occurred on September 3, 1934, Joe Huggins, the youngest son of Edward Huggins, was present, representing his father, who had died of colon cancer in 1907. The Hudson's Bay days were truly over.

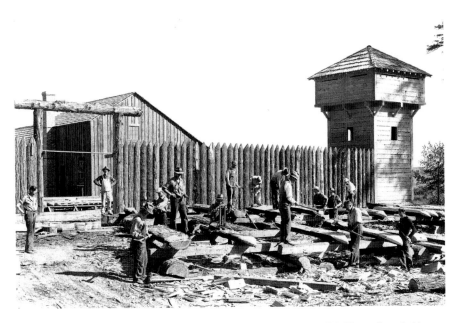

Workers complete the removal of Fort Nisqually to Port Defiance. *Washington State Archives, Archives and Records Management Division.*

It's easy to tell with a glance at a photograph of Fort Nisqually whether it was taken before or after the move from DuPont to Point Defiance, because while the relocated fort, erected in 1938, is designed with logs pointed at the top to make up a conventional stockade fence, the original fort had a palisade for only a short time in its history. And it was used not for military defense (the HBC/PSAC had good ties with Native Americans) but as a privacy fence. The palisade was built, as Clarence Bagley stated, "to keep local tribes from peeking." It may well have been similar to the way people stand around construction sites today to watch what's going on.

Often visitors to Point Defiance will come out of the barricade (which is made up of pointed logs), look down at the beautiful scene of the fort and the vast sound below and say, "Ah, yes. Can't you just see how it was?" In a way that's true; in its present location, old Fort Nisqually stands guard between the old world and the new one.

It should be remembered that at the time the fort was moved, the world was ramping up toward World War II, and the people in DuPont, far from being negligent, should be commended for doing everything possible to see

that these historic treasures got to a place where they could be sustained. The restored Fort Nisqually at Point Defiance lives on to teach and inspire daily.

In an 1841 sea voyage, Charles Wilkes gave the land the name Point Defiance because he thought that "if fortified it could bid defiance to all of the navies of the world."

Today, at Point Defiance, the restored Fort Nisqually is a living history museum staffed by employees and volunteers. A destination for tourists, it even offers on some occasions the fun and excitement of an escape room, where teams of visitors can utilize authentic historic artifacts as well as creative problem-solving skills to find their way out of an apparently escape-proof chamber. The experience is promised to "boast no modern technology." The idea is to give modern visitors a feeling for life in the 1800s, under the pressure of "winning the game under the pressure of time."

Two of the original buildings, the factor's house and the granary, remain in the Point Defiance location. In addition, there is a trade store, a working blacksmith shop, a laborers' dwelling house, a demonstration kitchen and

Fort Nisqually's original granary, one of the oldest buildings in Washington State, in its original location at Fort Nisqually. *State Library Photograph Collection, 1851–1990, Washington State Archives, Digital Archives.*

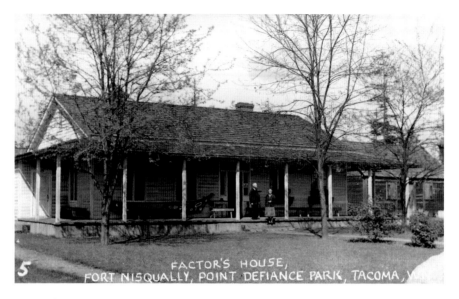

Factor's House, Fort Nisqually. Point Defiance Park, Tacoma, 1942. *State Library Photograph Collection, 1851–1990, Washington State Archives, Digital Archives.*

a kitchen garden. The factor's house is a proper American-style white house that just doesn't look as if it belongs among the rough buildings of the fort.

Drew Crooks provided this footnote: The original site remains protected and honored in DuPont. It was transferred to the nonprofit Archaeological Conservancy in 1993 and is occasionally opened to the public for educational programs and events.

THE TIME BETWEEN

There are now twenty-eight separate Indian tribes and nations in Washington. Steilacoom tribal elder Danny Marshall explained:

> *When the Changer came to Puget Sound, he saw that it was the best place to live. Instead of placing one Tribe of people here, he decided to rest and put the remaining people here in this one place. That is why there were so many Tribes on Puget Sound, each of them speaking their own language, and each of them responsible for a different part of the land.*

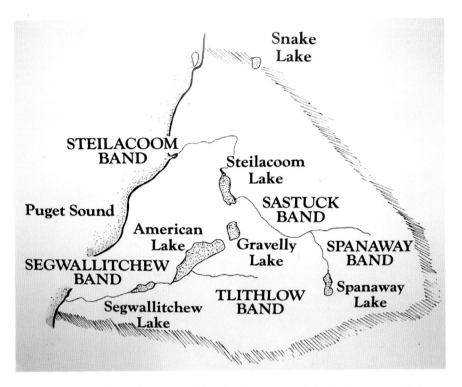

Tribal lands. Map shows placement of the tribes in the area of the Steilacoom people in western Washington. *Courtesy of Steilacoom Tribal Museum.*

The Steilacoom People are known today for being given responsibility for the mighty oak groves and the acorn. The Steilacoom are born to share the acorn with the other people. All the people love to share. Here on Puget Sound there is much to share.

Over the hills around Steilacoom, people from where the pink flower grows are seeing a resurgence of the beautiful blooms for which the tribe and the town are named. This is largely due to the work of local gardeners, especially Steilacoom resident Jim Senko, who has been responsible for creating parks and special plantings all over Lakewood and Steilacoom. Jim says he's found that the Steilacoom flower is a social plant. Attempts at growing it had failed because it couldn't survive being planted alone. Looking at Senko's close-packed blooms growing enthusiastically in a large wooden planter near his home, it's possible to imagine what it was like when the People of the Pink Flower moved through blossoms as far as the eye could see.

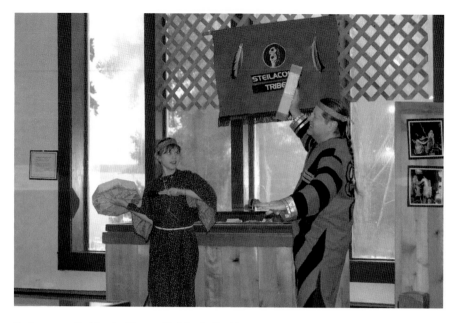

Steilacoom tribal leader Danny K. Marshall with granddaughter Shianna, performing Battle of the Winds. *Steilacoom Tribe, photo by Steve Thomas.*

The Hudson's Bay Company? Doing fine, thanks. In the day of Fort Nisqually, HBC was about the fur trade, blankets and agriculture; today, HBC (now owned by NRDC, an American private equity firm) has interests in Lord & Taylor and Saks Fifth Avenue. The Canadian Encyclopedia lists it as the oldest incorporated merchandising company in the English-speaking world.

Today, as a philanthropic project, Hudson's Bay Company creates a teddy bear each year to be sold for charity in honor of one of the founders of the company. In 2016, this was a Dr. Tolmie Bear, representing the chief factor of Fort Nisqually, resplendent in his clan tartan. I received one as a Mother's Day gift, and he was a great help in writing this chapter.

In this part of Puget Sound, stubborn determination is considered a virtue, and Jim Senko likes to point out what we call The Beaver Tree. A beaver literally chewed this tree almost in two. Trunk and branches don't seem to touch in any way, yet it continues to grow, serving as both inspiration and mystery.

The DuPont Museum and the Tourism Bureau work hard to tell the story of Fort Nisqually and all that came after. The Heritage Orchard near the site of the 1843 fort is being nursed back to bearing fruit. Hudson's Bay

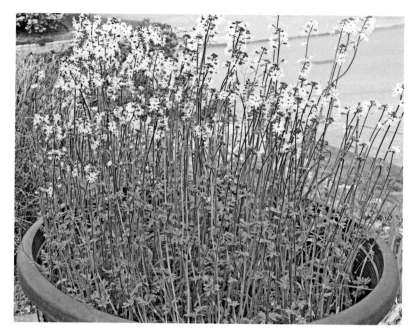

Steilacoom gardening expert Jim Senko and some other local gardeners are beginning to have success growing the Steilacoom Pink flower. *Courtesy Jim Senko.*

The Beaver Tree. This tree has been gnawed almost completely through yet it refuses to die and continues to grow. *Courtesy of Jim Senko.*

Company employees and the Huggins family planted the original trees in the nineteenth century.

Burton Foreman, a lifelong resident of DuPont who worked in the DuPont Munitions Factory, closes for us with these words written in another century, on September 13, 1970: "We walked through the orchard picking green apples and not giving a thought to the fact that once, long before our time, a whole village existed."

2

TUMWATER: THE OREGON TRAIL ENDS RIGHT HERE—AND HERE—AND OVER THERE

THE STORY THEY TELL

The Oregon Trail actually extended into what would become Washington State when pioneers decided to push on beyond the Oregon Territory. The Simmons-Bush wagon train changed the destiny of the Washington Territory when it set out from St. Joseph, Missouri, in 1844 for the Willamette Valley of Oregon. When the travelers arrived, exhausted and nearly starved, the leaders of the train were told "one of you can stay," but the other was informed, "We don't want your kind here." The leader who was declared welcome was Michael Simmons, but as the story goes, the other leader was George Washington Bush. He was black, and people of color were legally barred from the Oregon Territory with dreadful punishment for violation. Legend says that Michael Simmons retorted, "George Washington Bush is the best man of us. If he can't stay, none of us will stay!" True to their decision, they made their way across the great Columbia River and through the perilous Naches Pass to create the foundation for a state capital and a very famous beer—both called Olympia. (Historians in the area have asked me to make clear that the Simmons-Bush train had nothing to do with Olympia beer.)

The Rest of the Story: Simmons-Bush Party

Many historians credit the Simmons-Bush party for bringing the land north of the Columbia River—the present-day state of Washington—into the United States. Because they established themselves there so early, other settlers were attracted to join them. In time, this created a strong claim that would be invaluable in later disputes between Great Britain and the United States over the ownership of this land. This eventually determined the boundaries of the Oregon and Washington Territories. Furthermore, according to historian Don Trosper, who is a descendant of Jesse Ferguson of that original wagon train, the Simmons-Bush party did not travel the Naches Pass. They came up the Cowlitz River to Cowlitz Landing (current-day Toledo in Lewis County) and then slashed a trail overland on roughly what is today the old Pacific Highway (Old 99) to arrive at the falls of the Deschutes River in a trip made in the rain and cold of October. They called that extension of the Oregon Trail "the Cowlitz Trail." Legend has it that in her later life, Elizabeth Simmons, wife of Michael Simmons, said that of the entire trip out west, that little section between Cowlitz Landing and Tumwater was the worst part of the journey and perhaps the worst two and a half weeks of her life.

The Travelers

George Washington Bush was an unlikely hero. In fact, virtually all historians say with surprising passion that Washington (which appears in nearly all narratives of the journey) was really *not* (they say it like that) George Bush's middle name. TV historian Don Trosper noted:

> *Early records from Bush's days in Missouri and before do not show a middle name....His headstone here in Tumwater does not show a middle name....Family quotes and journals do not use a middle name...and there's hardly any source material from his era that mentions it. But if he wasn't named for the first president, he also wasn't any relation to the George Bush who became president.*

A little glitz is often added to give stature to larger-than-life characters. (After all, that Yankee Doodle Dandy, George M. Cohan wasn't really born

on the Fourth of July.) But no matter what his middle name, or even if he had none, George Bush got a lot done.

An only child, George Bush was born around 1779 (the exact date is uncertain) to a Philadelphia Quaker family, and young George apparently had a Quaker upbringing, which provided the strong framework for his life. George's father, Matthew Bush, was born in India, of African descent, and according to the *Olympia News*, he was brought to America as a young man before the Revolution by a British shipping merchant, noted simply as Mr. Stevenson, whose complete name seems lost in history's mists. It must have been a relationship that suited them both, because Matthew Bush worked for Stevenson most of his life. It was in the Stevenson household that he met the

George W. Bush (1790?–1863) was a key leader of the first group of American citizens to settle north of the Columbia River. *Washington State Library, Rural Heritage Collections.*

Irish maid who would become George's mother. They were married in 1778.

Very clear and all-American so far, but now we run into a little bit of a historical mystery. Pennsylvania had an anti-miscegenation law on the books until 1780, yet apparently there was no penalty for Matthew marrying his Irish wife. One historian says this "suggests that Matthew Bush was either not considered black, or he was married under the care of Germantown Friends (Quaker) Meeting in violation of the law." This also suggests that George Bush grew up believing that he had no more limitations than any other American. George's parents worked in the Stevenson home until his death. It appears that Stevenson had no other family, because he left Matthew Bush a substantial fortune.

As young men will do, George Bush wandered the country and tried his hand at many different jobs. He was working in the cattle business in Illinois by the time he was twenty.

Records of the time are sketchy, but it's reported that George joined the army, serving in the War of 1812, and he may have been at the Battle of New Orleans. Out of the army, he apparently became a voyageur and a fur trapper. As a trapper, it was inevitable that he'd end up working at least part of the time for the Hudson's Bay Company. When he was traveling for the HBC as a scout and trapper, there's some suggestion that he even

got as far as the Puget Sound, which would certainly have given a good perspective for future travels.

George Bush eventually settled in Clay County, Missouri, where he met Isabella James. Isabella was a young German American woman. The happy couple were married on July 4, 1830.

WEST WITH FAMILY AND FRIENDS

George Bush remained in Missouri for twenty years. He farmed and raised cattle, and the family was relatively well off. George Bush was middle-aged by any calendar, and again, Missouri had laws that forbade free people of color from entering the state. For Americans looking back today, it may be surprising to learn what a huge factor the atmosphere of bigotry and discrimination was in those formative years. At the same time, the Bush family began to hear the reports coming back from the first travelers to complete the arduous journey west to settle in the beautiful Oregon Territory. More and more the wind from the west seemed to carry the scent of freedom. The Bush family came to believe that the Oregon Trail would provide a path to making a living and allow them a life like any other American family, free of prejudice and limitations.

The Bushes had five sons before the family headed west. Any mother who has tried to negotiate a trip to the mall with even two or three youngsters supplied with a backpack and ready juice boxes will appreciate what an incredible undertaking this was.

According to Bush family lore, in 1844, George Bush and his family—along with five other families, including his friend Michael Simmons—left Missouri, heading west on the Oregon Trail. Bush had gained incomparable navigation skills and knowledge of the western region during his years as a trapper, which made him an indispensable guide and one of the leaders of the party. Isabella was a trained nurse. That was an invaluable addition to the venture. It's easy to imagine the comfort of knowing there'd be someone to help in the medical crises that would be all too common on the trail.

The Bush family tells the story that George Bush built a false bottom in his wagon, where he hid a fortune of somewhere between $2,000 and $5,000. His granddaughter said it was over five thousand silver dollars and some gold bricks, because the journey ahead would be long and filled with unexpected difficulties. Bush felt especially confident even faced with the

long, hard trip because his close friend Michael Simmons was one of the other wagon masters. Simmons was a man he'd trust with his life.

George Bush was known to be generous and caring, so it's not surprising that in outfitting the party for the arduous trip, he bought six Conestoga wagons, equipping each with enough provisions for a year. As he prepared for the trip west, he carefully included species of fruit and shade trees. These would prove to be enduring treasures ultimately planted on his farm at Bush Prairie, where some survive today. But that's getting ahead of the story.

MICHAEL SIMMONS

The families of Michael and Elizabeth Simmons, James and Charlotte McAllister, David and Talitha Kindred and Gabriel and Keziah Jones joined the Bushes on the journey that would make them the first U.S. citizens to settle on Puget Sound. The five families were all friends and neighbors—and relatives—in Missouri. Simmons's sister Charlotte was married to James McAllister, and Simmons's wife, Elizabeth, was David Kindred's sister.

Another member of the train who would prove important in the development of the Puget Sound area was a twenty-year-old named Jesse Ferguson. Historian Don Trosper, a descendant, recalls Uncle Jesse's part of this historic train and noted that "the Simmons/Bush party joined a larger train heading west. Michael Simmons was elected to be the second in command for the entire train. It was organized in a military manner. The leader, Cornelius Gilliam, was the general and Michael Simmons received the honorary title of Colonel, a title he carried until his death." Members of the group called themselves the "Independent Colony." They were forty-eight families in seventy-two wagons. They were on their way.

So they set off along the Oregon Trail, a trail that was still new and not yet deeply marked by the deep wagon ruts and occasional ATV tracks that we see in John Wayne movies. In fact, it was little more than a roughly indicated path. They planned for every predictable crisis, aided by George Bush's knowledge gained in his years on the trail. They tried to pick the best time of the year to travel, but of course, this was before the day of accurate weather forecasts. Almost immediately, they were beleaguered by constant rain that they couldn't outrun. That meant that the travelers could never be dry. Their clothes would stay wet. The smell of mildew

Right: Michael T. Simmons (1814–1867), Thurston County pioneer, n.d. *Washington State Library, Rural Heritage Collections.*

Below: The Oregon Trail called many travelers to a new life. *Oregon Historical Society.*

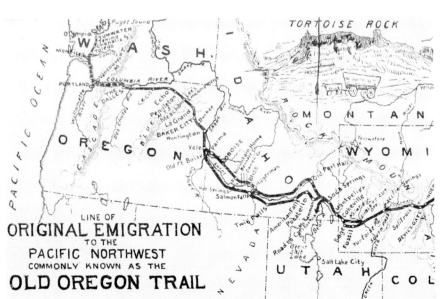

LINE OF
ORIGINAL EMIGRATION
TO THE
PACIFIC NORTHWEST
COMMONLY KNOWN AS THE
OLD OREGON TRAIL

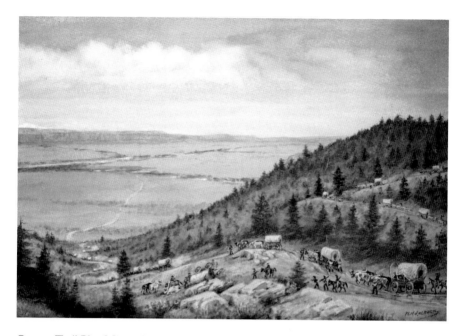

Oregon Trail Blue Mountains. *Jackson, William Henry. Blue Mountains. 1929. Watercolor. Scotts Bluff National Monument, Gering, Nebraska.*

would be constant, and that was just the start. The rain eased, stopped and then incredibly turned to drought. The travelers continued somehow through all of the shortages and disasters that they had planned for and the ones that couldn't have been imagined. Of course, there were births, but the train couldn't stop; they had to get to Oregon before the winter came. It is soul-curdling to imagine giving birth in a jolting wagon, but they managed, sometimes with tragic results. At least one woman, newly widowed by cholera, managed to bring a baby girl into the world. Then, the poor woman fell out of the wagon and her leg was broken as the wagon passed over her. The baby lived, but the mother did not.

Folklore attributes humorous and surprising moments to "Mrs. Simmons's journal," which supposedly told of an encounter with a Native American tribe. Of course, they did not know each other's language. One of the visitors admired Bart and Rachel Kindred's baby boy—and rode off with him. There was great confusion, doubt and worry as to what would happen, but the visitor came riding back with the happy baby, who was wearing a new buckskin shirt and beaded moccasins, a gift from the Native American's wife to the new neighbor. It's hard to locate copies of

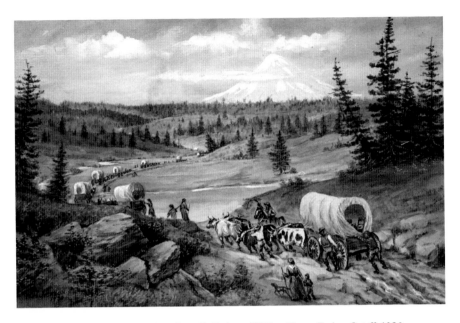

End of the Oregon Trail (Barlow Cutoff). *Jackson, William Henry. Barlow Cutoff. 1930. Watercolor. Scotts Bluff National Monument, Gering, Nebraska.*

the journals the travelers kept, but we know they wrote of routines, of arguments, of hunting for elk and antelope. There was what must have been the terrible moment for Elizabeth Simmons when her heirloom oak chest had to be abandoned at a crossing of the Platte River when every bit of extra weight had to be jettisoned for the river crossing. Of course, the trail's edge was a graveyard for household treasures deemed too precious to leave behind that ultimately could not make the journey.

CHANGE OF DESTINATION

The Oregon Trail journey was every bit as difficult as the stories had predicted. The travelers set off in May and didn't reach The Dalles (Oregon Territory) until late fall. They sent a scout out into the Willamette Valley, and the report that came back made their blood run cold. As the travelers made their way west, the unthinkable had happened. The provisional government set up in Oregon Territory by settlers from the United States

had enacted legislation, like that of Missouri, barring settlement by African Americans. Violators were to be whipped every six months. That meant that the Bush family must immediately move on. The Bush family was considered indispensable, so Simmons and the other members of the party gave up their plans to settle in Oregon's Rogue River Valley.

After much discussion, Simmons summed up the feelings of the group by stating, according to some accounts, that if the Oregon settlers wouldn't allow a family of such fine character to settle there, then none of the party would settle there. Murray Morgan wrote in *Puget's Sound: A Narrative of Early Tacoma and the Southern Sound*:

> *There is no hint in any known journal of the influence the black exclusion law had on the decision of the Bush-Simmons group to settle not on the "American" side of the river but on the north, where the Hudson's Bay Company dominated, and soon afterwards to migrate to Puget Sound. The journals and later volumes of reminiscence speak only of love of country, of the desire to penetrate an area from which the HBC sought to exclude Americans.*

According to the Oregon Trail History Library, the Hudson's Bay Company officially attempted to dissuade Americans from settling north of the Columbia. However, Dr. John McLoughlin (1784–1857), who as the chief factor in charge of Fort Vancouver was the most powerful figure in the Pacific Northwest's small community, helped them just as he helped those settling south of the Columbia. Under McLoughlin's direction, Fort Vancouver not only employed the men in cutting timber and making shingles but also provided the Simmons party with supplies at good prices and on credit.

Covered wagon on trail. Oregon, Her History, Her Great Men, Her Literature, *written and published by John B. Horner, 1919.*

Don Trosper commented that in those days, the ability to work and produce usable goods was as valuable as money, so the addition of these travelers who could and would work hard was very important.

The Oregon Trail History Library goes on that Simmons rented a three-walled sheep pen at Washougal, paying a Hawaiian a yellow, homespun shirt (well worn) for the privilege and moved his family in.

Once again, the travelers were in a perilous situation. The bridge across the Columbia River was more than seventy years away, so they had to find materials to piece together barge-like vessels to ford the mighty waters. The 1818 Treaty of Joint Occupation placed the Oregon Country under joint British and U.S. control while the British Hudson's Bay Company still dominated the territory north of the river.

MOVE TO PUGET SOUND

In the summer of 1845, Michael Simmons led an exploration party around Puget Sound, while the others remained on the Columbia, where Bush had charge of the families' livestock. Simmons found a site for a settlement at the falls where the Deschutes River enters Budd Inlet in what is now Thurston County. In October 1845, the Bush, Simmons, McAllister, Kindred and Jones families, accompanied by two single men, Samuel Crockett and Jesse Ferguson, set off from Fort Vancouver for Puget Sound.

They traveled down the Columbia to the Cowlitz, and up that river to Cowlitz Landing. From there, they spent fifteen days making a road through the forest to Budd Inlet, which they reached in early November. Simmons and his family settled there at the falls of the Deschutes, and Simmons laid out the community he called New Market, which later became Tumwater. The Bushes and others settled farther up the Deschutes River, a few miles south of New Market on a fertile open prairie that soon became known as Bush Prairie.

Having arrived so late in the year, the new settlers hurried to construct crude log cabins before the winter set in. For food that first year, they largely depended on the generosity of their neighbors—the Hudson's Bay Company outpost at Fort Nisqually farther north on Puget Sound in what is now Pierce County, and the Nisqually Indians whose lands extended on both sides of the Nisqually River (now the border between Thurston and Pierce Counties).

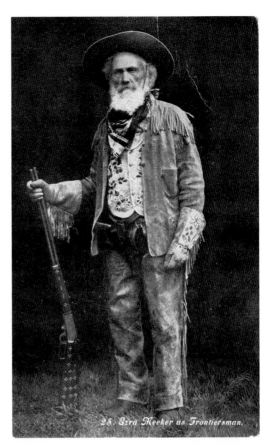

Right: Ezra Meeker, Puyallup pioneer whose lifetime spanned ninety-eight years from the Oregon Trail to a ride in an airplane. *University of Washington Libraries*.

Below: Ezra Meeker at the end of the Oregon Trail. *University of Washington Libraries*.

McLoughlin had provided the party a generous letter of reference to Dr. William F. Tolmie, his counterpart at Fort Nisqually: "They have all conducted themselves in a most neighborly, friendly manner, and I beg to recommend them to your kind assistance and friendly offices."

With this letter, the families were able to purchase wheat, peas, potatoes and beef cattle at Fort Nisqually on credit. Interestingly, of the five family names, only Bush does not appear on the fort's credit list, apparently corroborating that they brought sufficient cash to pay for their supplies.

They settled at the falls of the Deschutes River. They first called the settlement "New Market," but the thundering falls of the Deschutes River made a drumming sound that the local Indians called "Tumwater," and that was the name that stuck. There the Bush Farm was built.

Travelers can still see the Bush Farm, now called the Bush Prairie Farm. It was located just off the "old highway 99SE" running south from Tumwater to Cowlitz Landing and Vancouver, so most new immigrants, some half-starved from the journey, passed it on their way to Puget Sound. The newcomers were dependent on established settlers for food and seeds to start their own farms, and the Bush family was generous in offering assistance. That help was especially important in 1852, when the large number of immigrants exhausted most of the region's grain harvest, and the Bush farm was one of the few with supplies available. The Oregon Trail History Library provides some details of those first industrious years.

Bush and Michael Simmons built the area's first gristmill and sawmill in 1845, and Bush helped finance Simmons's logging company. Bush introduced the first mower and reaper to the area in 1856. In addition to their farm, the Bushes ran a roadside hotel, which was free to anyone traveling between Cowlitz Landing and Puget Sound. The Bushes would give visitors a good square meal and parting gifts of grain and fruit grown on their farm.

Ezra Meeker (1830–1928), who was among the 1852 arrivals and went on to become founder of Puyallup and one of the foremost pioneer leaders, recalled that Bush gave out nearly all his crop that year in a gesture like Jimmy Stewart's in *It's a Wonderful Life*.

"Pay me in kind next year," Bush would say to those in need, and to those who had money, he would say, "Don't take too much—just enough to do you."

DISCRIMINATION AND EXCEPTION

George and Isabella had decided before they left for the west that if George was not permitted to have all the rights and prerogatives of a free man in Oregon Territory, they would go on to California or New Mexico. Both of these regions were then under Mexican rule, and the Bush family hoped for a better life in another country.

The Oregon Treaty of 1846 ended the joint administration north of the Columbia, placing Bush Prairie firmly in the United States. Ironically, by staking an American claim to the area, Bush and his party had also brought Oregon's black American exclusion laws. That meant the title to their land was no longer clear. These laws would not apply if the territory belonged to the British Empire. When the Washington Territory was formed in 1853, one of the first actions of the territorial legislature in Olympia was to petition Congress to give the Bushes free, clear ownership of their land, which it did in 1855. So it happened that George Bush was among the very first African American landowners in Washington State.

HELP FROM HUDSON'S BAY
AND THE NISQUALLY TRIBE

The Pacific Northwest Forum (Spring 1982) notes that the Hudson's Bay Company had good relations with the twenty-six tribes of Puget Sound Indians, whom they treated as trading partners and allies. With Tolmie's encouragement, the Simmons party followed that example. They were welcomed by the Nisqually Indians led by Leschi, the famed tribal leader. The Native Americans brought with them many horses loaded with supplies. Local Indians taught the newcomers from the Midwest to take advantage of the unfamiliar seafood with which the region abounded. They soon learned to find oysters, dig for clams and harvest salmon returning up the rivers, as well as to use many native plants.

All the members of the Bush family learned the Nisqually language. They became close to Leschi and other Nisqually who frequently visited their farm. George and Isabella Bush's youngest son, who was born at Bush Prairie in December 1847 (and died in 1923), was named Lewis Nisqually Bush. The Bushes helped to treat their Indian neighbors when epidemics carried by the newcomers swept the region.

AIDING NEW ARRIVALS

The weather was unusually harsh the first few years following the settlement, and the first harvests were small. But Bush was a skilled farmer, and the farm began to thrive. By the winter of 1846–47, Bush and Simmons set up a gristmill on Simmons's claim at the Deschutes Falls. For the first time, the settlers could grind their own flour instead of depending on Fort Nisqually. Simmons and others also set up a sawmill, and the growing community was able to gain some cash income by selling lumber. Ezra Meeker planted two acres of hops. This became the beginning of an economic empire in the Puyallup Valley, as he promoted Northwest-grown hops in New York and London and became the "hop king" and one of the wealthiest men in Washington Territory, according to Dennis Larsen in *The Hop King*.

Don Trosper adds this historical note:

> *The City of Tumwater, located at the southern tip of Puget Sound next to our State Capitol [sic] of Olympia, is historically significant for two main reasons: one reason is that it was the home for the famous Olympia Brewing Company founded in 1896 by the Schmidt family, the other is that Tumwater is the first permanent American community in what is today the State of Washington. The eldest son William Owen Bush took over the*

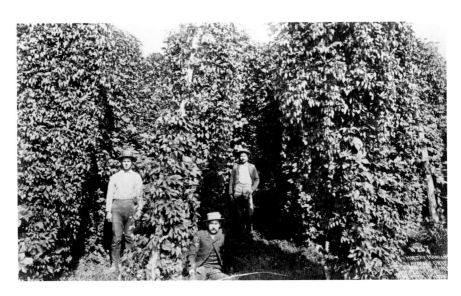

Workers in Ezra Meeker's hop fields. *University of Washington Libraries.*

farm after the parents passed away and won national awards for the various crops and grains grown on that farm. He was also a representative in the first State Legislature and was instrumental in forming the agricultural college that became Washington State University in Pullman. He was a tremendous promoter for agriculture in our state.

THE HAPPY ENDING

History indicates that George and Isabella brought many trees with them on their journey from Missouri. One of the original trees still lives on the Bush Farm in Washington. According to the present owners, DNA testing shows this tree as the oldest living butternut in America, maybe the world. Yes, the 174-year-old butternut brought from Missouri is still alive, though much damaged by the years. There are two younger trees on the farm as well. It is a pure strain, unlike the hybrids found in other parts of the country.

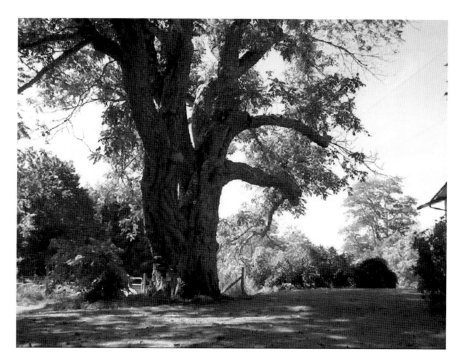

Oldest butternut tree in the United States, possibly oldest in the world. George Bush tenderly carried it in his wagon across the nation. *Courtesy Mark and Kathleen Clark.*

Unfortunately, it sits right in the flight path of the Olympia Airport and was poorly pruned about fifty years ago. In spite of all this, the tree lives on and has produced many offspring, two of which are on the farm and one small one recently moved to the state capitol grounds in Olympia.

Today, Mark and Kathleen Clark own a portion of the original Bush Farm. The Clarks, high school sweethearts who met as students at Tumwater High and married at nineteen, purchased 5 acres, which they use as a community-supported agriculture farm supplying fresh vegetables grown without insecticides. The Bush Farm was a full section of about 640 acres. The Clarks' piece is the site of the Bush home and barn, so it is a key strategic site to preserve for posterity. The Clarks are proud that "we have our land in a perpetual easement which extinguished the development rights." It is the Clarks' goal that "it will be Farm and history forever."

Olympia: John Wayne Didn't Settle the Territory, Neither Did Julia Child

The Story They Told

Anybody can tell you what happened on the wagon trains coming west. We all learned from the movies what life was like on the Oregon Trail—lots of picnics, and even though there may have been flood and privation, manicures stayed perfect and clothes never wrinkled. Plenty of time for reflection and passion on those long, starlit walks.

In fact, although the Great Migration, in many ways, set the character of settlers in the West, several sources say that many Americans have little idea of what the move west really involved, having gotten most of their information from movies, television and video games.

The Rest of the Story

Middle school teacher Robert Cooksey became so distressed at how little his students really knew about the courage and privations of the early settlers that he designed a new curriculum (now used by the Tumwater School District for twenty-five years). He felt that there was much to be learned from the struggles of the pioneers, and this award-winning class required the students to live as if they were actually on the Oregon Trail.

Homesteader students with teacher, preparing for activities that would have been recreation in pioneer days. *Photo by Robert Cooksey.*

The Homesteaders Class was much different from board and computer games because it required the students' physical commitment. It also required the young pioneers to think ahead about what provisions they'd really need, whether oxen would be the best choice to pull a wagon, if they needed a wagon or if they should try to join someone else's party? A key element is that games rely on the fact that participants win by getting to the West first, having the best plot of land or getting a head start on their fortune. But in real life and the Homesteaders Class, teamwork and planning were the winning elements. It can be pretty challenging just to think about, starting with the fact that students were required to come to every class in pioneer garb. Now, there are obvious problems with this, since it would be downright inconvenient to spend the day in twenty-first-century classes wearing nineteenth-century clothes, but the students created practical workarounds and turned up for class suitably garbed to learn pioneer crafts and mindsets. It was more difficult for girls—while men's garb hasn't changed appreciably in the last 150 years, except for the cut, the fabric and lack of zippers on pants, women wore long, cumbersome skirts that got in the way when they

tried to work, walk or deal with necessary tasks. In fact, the heavy skirts were such a problem that one historian told me that falls downstairs were the second-most common cause of death in women after childbirth. It's easy to see why, a woman trying to manage her skirt, carry a candle and perhaps laundry or a baby, would be at a disadvantage trying to manage a narrow stairway. For the Homesteaders Class, many of the girls created clever one-piece garments that slipped over the head like a poncho and tied at the waist. I saw a couple of young women throwing them on as they raced from one class to the next, and I hope they got extra grade points for creativity.

This is how the course outline describes the challenge:

> *The pioneer experience, of course, begins with a simulated two-thousand-mile trip in which students study the westward expansion of the United States. Students develop a trail persona and form families. They make family decisions about which supplies are crucial to the success of their journeys, pack their wagons and head out across the plains.*

The plan was for students to do all of this by studying journals and diaries from the early settlers.

Robert Cooksey, who taught the Homesteaders Class for twenty-five years, shared some of the accomplishments that came from it:

> *During the school year, students researched both primary and secondary resources covering pioneer life, skill, mannerisms and language since common terms have changed since the 1800s. (For instance,* Bags o' Mystery *for* sausage *and* Collie Shangles, *Queen Victoria's own term for quarrels).*

> *Homesteaders began the year learning about pioneer attire and how it could create the "illusion" of being a youngster in the 1800s. The homesteaders then went to Fort Nisqually (Point Defiance Park), where they observed an example of modern reenactors creating an illusion of time travel using attire, language, mannerisms and historically accurate topics and facts. All of these skills would be taught to, and practiced by, homesteaders during the school year, culminating in the "Pioneer Fair" reenactment by our eighth grade homesteaders for the fourth grade students from each of the six elementary schools in the Tumwater School District.*

As part of their "community involvement," which matched the district's strategic goals, all homesteaders were required to participate in two

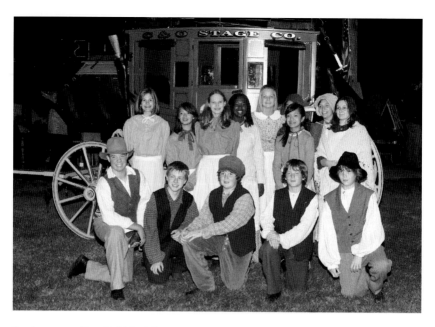

Students actually refurbished the stagecoach. Blacksmithing classes taught necessary skills for getting it all together. *Photo by Robert Cooksey.*

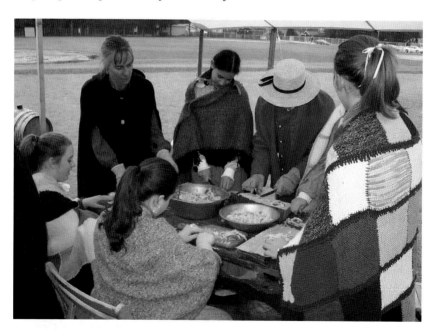

Girls engaged in candle-making, a cold, lengthy process. The activities were designated "men's work" and "women's work," as they were categorized in the 1800s. *Photo by Robert Cooksey.*

community service events during the year. The purpose of the required community service was meant to foster a sense of community involvement while teaching students about the heritage of the community in which they lived. The first opportunity for students to practice their new skills was the annual Cider Sunday event. Students learned nineteenth-century methods of preserving food—in this case, apples and cider—then put their knowledge to work. Cider Sunday was an event for the public, working with the Tumwater Historical Association. Students learned firsthand how tiresome using a hand-cranked cider press was and discovered by experience what pioneers had to endure on a daily basis while surviving on the frontier. Many students would comment on their experience that while the loose-fitting attire of the period was good, there were also times where it was hot and/or cold and uncomfortable after a day's work. Students acquired a newfound appreciation for comforts at the end of a day like a hot shower and then relaxing in front of the television or computer.

Another event was a fall activity in which students would render fat to make tallow for candles. Students learned the process of making candles

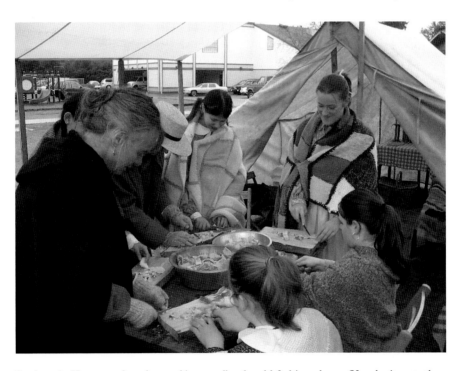

Students in Homesteaders class making candles the old-fashioned way. (You don't go to the craft store; you start by cubing pork fat for tallow.) *Photo by Robert Cooksey.*

from scratch, from trimming meat off the fat, rendering (a fancy way of saying boiling) the fat to release the tallow and repeatedly dipping the wicks in tallow to form candles. Students found out that this task was essential, as candles provided the only source of light for pioneers (besides the fireplace) at night. It was also the first opportunity students had to "teach" this skill to members of the community. For many years, it helped the Littlerock Elementary PTO with its fundraising.

At the end of the year, the homesteaders to put all of their knowledge and skills to a test. They became the teachers of history to the fourth grade students from the six elementary schools in the Tumwater School District for two days and spent a third day teaching the public about the heritage and history of Tumwater. This fit into the fourth grade curriculum, which had students learning about the Oregon Trail. The elementary students, and occasionally homeschool students, heard historically accurate conversations between young people from the 1840s about events of the Simmons-Bush wagon train as it traveled from Missouri to New Market (Tumwater). Then homesteaders taught hands-on pioneer skills to the fourth graders, including everyday skills like churning butter, grinding wheat, laundry (with lye soap and a washboard), carding, spinning and knitting wool and blacksmithing. The fourth grade students also played pioneer games, which required nothing more than basic toys or some imagination. The interest shown by fourth grade students in these simple games and the fascination of eighth grade homesteaders in teaching what they studied over the year can be summed up in two examples. More than one of the fourth grade teachers commented that their students, especially those who struggled to stay focused on a task in the classroom, were entranced by the simple lessons and hands-on tasks taught by the homesteaders. Equally important is the enjoyment of homesteader students, many of whom had struggled with talking in front of a group, who now became the teachers of history to a younger generation. They came away asking if they could do this again and again. The lesson is that giving students a sense of empowerment and encouraging a work ethic has a positive impact on more than one generation of students. It also provides a strong connection to their community and its heritage.

With the money students raised selling their goods at various fairs and community events, they were now ready to outfit their covered wagons, using dimensions and supply lists from the actual wagons that made their way west. If they weren't able to outfit their own wagon, they would be faced with trying to convince some other wagon's inhabitants to take them along—

perhaps by demonstrating a skill, like iron mongering or valuable nursing ability. This provided students with an opportunity they couldn't have had otherwise, and there was at least one wedding between class members, many years down the road.

Having arrived in New Market, the homesteaders set about creating a community. They read about the events of those early years, 1845 through 1850, and they polished their personas of the residents of New Market. They became the children of Michael Simmons, James McAllister and Gabriel Jones, just to name a few. They practiced speaking the language of the time, had lessons in Victorian etiquette and composed dialogues in which they conversed about current events in New Market.

Robert Cooksey subsequently received the Washington State Governor's Award for Excellence in Teaching History. This program was founded at Tumwater Middle School by Cooksey and Brian Buntain with colleague Anne Kelleher. It has, for more than twenty-five years, fostered an interest in history, the heritage of the Tumwater community and the state of Washington in over 1,600 eighth grade students and over 14,000 fourth grade students. When the class is over, the students have learned valuable lessons about the pioneer experience. They also have fulfilled their Washington State history graduation credit requirement. The unique part of this, the teachers report with gladdened heart, is that each student remembers at least one idea, fact or skill he or she learned during this process from a class in Washington State history. Many students remember nothing from the traditional class. This is real progress!!

4

BONNEY LAKE: THE LONGMIRE JOURNEY? THAT WAS NO PARTY.

THE STORY THEY TELL

In the lush prairie and heavy forests around the small, friendly town of Bonney Lake, there are places where you can still see the wagon trail that brought travelers like the Longmire Party to Puget Sound across the Naches Trail in 1853. The story is that members of the Longmire party killed their oxen and braided their hides into ropes to drop wagons down the mountain in areas so remote that local lore says Sasquatch was born here and at night you can hear that creature howling while pitching rocks and pine cones at campers and remote homes.

THE REST OF THE STORY

Let's start with Sasquatch. You may call him Bigfoot, depending on the closeness of your relationship, but people here are pretty sure that if you stay around, there's a fair chance you'll meet him, secluded in the forests that have been undisturbed since the beginning of time. The town of Bonney Lake is thought by many to be the area of origin of the Sasquatch.

When we taped our show in Bonney Lake, our host, a city official, took us to a very high ridge that looks down upon the wide prairie. (This is the

Right: Please do not feed the sasquatch, "official" trail sign. *Shutterstock*.

Below: Bonney Lake, a city of contrasts. Stalled in traffic? You can at least enjoy the mountain. *Courtesy City of Bonney Lake*.

same ridge the schoolchildren will head for when fleeing a lahar if Mount Rainier erupts.) For non-volcano watchers, a lahar is the destructive mud and debris flow that occurs when a volcano erupts. Rebecca Lindsay wrote in NASA's *Earth Observatory* that when Mount St. Helens erupted in 1980, the lahar buried fourteen miles of the Toutle River with as much as six hundred feet of dirt rocks and trees and sheared off whole ancient forests as if they were toothpicks, mowing down four billion board feet of lumber. Even though Mount Rainier is our neighbor and we feel we know all of its moods, it's surprising to realize it's rated as the third-most dangerous volcano in the United States.

Standing there and looking down, I could see huge indentations, filled with water, running across the prairie floor. "Sasquatch prints," our host solemnly declared. They did look like giant footprints. You could almost see how the huge heel would strike, allowing water to seep in, and the toes would squish down. The tracks were made, I was told, still perfectly seriously, that when the sasquatch were out hunting one day, long ago, they saw a fine

Puget Sound and Mount Rainier. *State Library Photograph Collection, 1851–1990, Washington State Archives, Digital Archives, www.digitalarchives.wa.gov.*

Lordly Monarch of the Western Wilds—Look for him in Mount Rainier from Bonney Lake. *The Miriam and Ira D. Wallach Division of Art, Prints and Photographs: Photography Collection, The New York Public Library digital collections, ca. 1895–1920.*

fat elk. Naturally, they chased it, and naturally, the elk was faster than they were. But the great hairy beasts would not give up, although at least one researcher says Sasquatch would rather have sandwiches or perhaps candy corn. Apparently, the sasquatch spend their lonely nights in the wilderness longing for candy corn rather than elk.

However, the website of the Washington Sasquatch Research Team says that they eat pretty much what any animal eats. On this day that my host described, the sasquatch were so intent on the chase that they chased the elk right into the mountain. The elk are still there. From Bonney Lake, you can see them quite clearly looking back at you, outlined in blue on the snow.

The Bigfoot Research Organization website shows Washington has far and away the most sasquatch sightings. There have been a total of 643 reported sightings of the hairy creature in this state, with 77 sightings reported in 2017. Astonishingly, the next highest number of sightings were in Florida, with 314. Everybody needs a vacation.

As this book was coming together, Washington State representative Ann Rivers brought a bill to the state legislature naming Sasquatch as the state cryptid. A *cryptid* is a creature whose existence can't be proven, but it can't be disproven either. Not all states choose an official cryptid, but if the two bills pass, sasquatch license plates would be created, and sales of the special plates would raise money. The specialty plates would cost forty dollars, with a thirty-dollar annual renewal fee.

"The strong positive reaction to my bill to make Sasquatch the state cryptid proved that people of all ages are still taken by the idea that such a creature is out there. I have no doubt that some of them will like the idea of a sasquatch license plate and appreciate that buying one is good for the park system," Rivers said. The bills are moving through committee at this writing.

I interviewed a couple who were retired from the Air Force and were stationed in the area in 1968, stayed on as home owners since 1977 and are very level-headed members of the community. They recalled being out camping with young children when their dogs became very frightened, trying to get into the tents and behaving strangely, as rocks and pine cones were being thrown into the camp. "We knew it wasn't bears," the wife said, "Bears don't throw rocks at people." "I don't tell this story often," she reflected. "I just don't tell too many people that the dog peed all over me."

Two days later, one of the couple's daughters heard footsteps and animal screams. Police found a footprint that was sixteen inches long and seven inches wide with five toes two inches long. No arrests were made. I do not tell this story to be frightening, although it is a great story, but to point out that this is still a country where the unexpected can be expected at any minute.

So this was the wild, strange land into which members of the Longmire party traveled when they crossed the Naches Pass in the fall of 1853 with a train of thirty wagons. James Longmire wrote in his memoir of starting from his home in Shawnee, Indiana, with his wife and four children on March 6, 1853. Their great luxury was a camping oven, for which they paid twelve dollars, Longmire reported.

This wise purchase of cooking equipment weighed only twenty-five pounds and allowed the family to have warm biscuits for breakfast. Every ounce and every penny had to be counted, as nearly every wagon would have to discard many precious items to save the oxen on the trip.

By late September, they had reached the Naches River, and Longmire recalled that they crossed the river sixty-eight times, for a combination of reasons. They might find a relatively safe crossing point on the river, but when they reached the other shore, would be able to travel only the shortest distance before the forest or terrain was impenetrable and they'd have to cross again.

The party at last came to the summit of the Cascades, twenty-five miles from the summit of Mount Rainier and to what are called the Naches Trail Cliffs, so perpendicular that it seemed there was no way to go forward. They decided they'd have to tie ropes together and lower each wagon. George Hines was nine years old, and he remembered the perpendicular

bluff. As superintendent of the Oregon Historical Society, he wrote to Ezra Meeker about the experience. The area was composed of heavy timber, so there was no other way down. "So the longest rope in the company was stretched down the cliff." There was just enough rope, Hines recalled, to wind twice around a small tree to stabilize the wagon. But the rope was far too short to lower the wagon to the water below. "Then James Biles said 'Kill the poorest of my steers and make his hide into a rope.'" George Hines says that three animals were slaughtered before a rope could be made long enough to let the wagons down. It took two days to make the descent with all of the animals.

There has been some question as to whether a nine-year-old could accurately remember this incident, but one need only look at the terrain today to know that the difficulty couldn't be exaggerated.

The irony is that this treacherous route was taken because Longmire misunderstood helpful directions from an Indian who had been accompanying the train. "They saw that we were lost," he said, "and got off their horses. He cleared a small patch of ground and marked two roads, making dots along the road, the latter having more than the former. He pointed to the dots and said *sleeps* and *soldiers* which were really the only words they could understand." The party decided to take the road with fewest *sleeps* but learned later that the other road led easily to Fort Colville. Longmire thought for a long time that the Indians had led the party into a trap, but came to understand over the years that they had been trying to help. It's so hard to imagine, setting off without even a compass, but Longmire said, "We would have known little more if we'd had one."

The journey was one struggle after another. The party was helped by Andy Burge from Fort Steilacoom, who gave them supplies meant for road builders from the fort. The workers had given up and left because they had no food. The supplies arrived too late for them, but Burge shared with the travelers. Longmire reported that Burge helped where he could by blazing trees to make a trail and leaving encouraging notes tacked up, "preparing us in a measure for what was before us." *The road ahead is a shade better* one note said. A little farther on was a very welcome wagon full of food.

The winter after they arrived, the Longmires settled on their donation claim. Said pioneer historian Elwood Evans:

Through the mountains a trail had been blazed—nothing more...fallen trees, the growth of centuries laid across the path. To call it a road was an abuse of language; but over it and by it did those immigrants of 1853

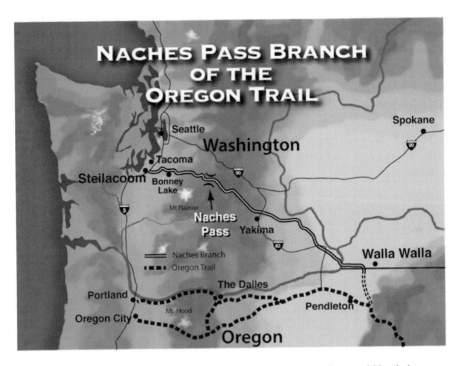

The Naches Pass was not user friendly, but it brought travelers to what would be their own backyards. *Permission of Jerry Bates, Oregon California Trails Association, 2018.*

travel in their journey to Puget Sound with an axe in hand hewed their way through a mountain gorge…over a road built as they marched.

In the summer of 2011, a team of citizens, along with employees of the Bonney Lake Geographic Information System Department, began walking the trail, attempting to map exactly where the first settlers passed through the city on the Naches Trail. According to Brian Beckley in the *Bonney Lake–Sumner Courier-Herald*, to start, GIS Analyst Allan Catanzaro took an 1872 map from the U.S Department of Interior General Land Office Map and used the public lands grid to match the original map with a modern, digital equivalent. Once that was completed, the Naches Trail, which appears on the 1872 map, was superimposed on the current map, giving the city a general route.

Mount Rainier clearly had a very big impact on James Longmire. He returned to it many times, guiding climbers and making discoveries. He discovered the hot springs at what is now called Longmire along the Nisqually River southwest of Mount Rainier's summit, which the family

Mount Rainier undergoes significant activity every five hundred to one thousand years. It has been five hundred years since the last big explosion. *Library of Congress, Prints & Photographs Division [LC-USZ62-101044].*

developed into a major tourist destination. Longmire's sons followed in his footsteps as guides and explorers on Mount Rainier and named many of the features around the mountain.

Lou Palmer wrote in one of a series of interviews that the old frontiersman still made early spring tips to his place there with his riding horse, which was "deaf as a post." Palmer also reported that Longmire brought along his packhorse Snoqualmie, which had ascended to the highest elevation of Rainier ever reached by a horse and made more trips across the high Cascades than any other horse. He never mentioned whether he saw the elk in the mountain.

5

Spanaway: Mrs. Mahon's Tablecloth

The Story They Tell

At the Prairie House Museum in Spanaway, I saw Elizabeth Mahon's tablecloth, tattered and missing chunks of fabric, on display. The story that went with it was of a warm and hospitable pioneer wife who lived near the place where travelers across the Oregon Trail and the Naches Pass ended their journey in Washington Territory. When she learned that a wagon train was coming, the story went, Elizabeth Mahon would cook a big dinner, set the table with her best tablecloth and china and go out to meet the travelers. She'd bring them in for a hot meal after the hard journey. That was why the story of Mrs. Mahon's tablecloth resonated with me. We even produced a TV spot suggesting that this was the beginning of famed Northwest Hospitality (we definitely said it with capitals). The story concluded with the surprising twist that she is buried on the Brookdale Golf Course. But then the facts began to get in the way.

The Rest of the Story

The first travelers didn't come across the Naches Trail until 1853, and the Mahons were already settled in their own home in the Puget Sound Area by that time. In fact, in Fred Tobiason's meticulously researched book on

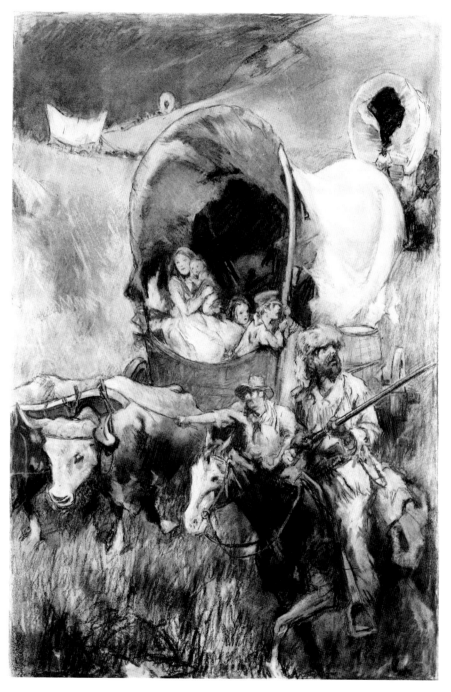

Hard crossing. *The National Oregon/California Trail Center, Montpelier, Idaho.*

fish and wildlife in Clover Creek, he wrote that in 1852, Christopher and Elizabeth Mahon homesteaded 640 acres on the present-day Brookdale Golf Course, Mayfair area, from Waller Road to Golden Given Road and between 125 Avenue East and 152nd Street East. Tobiason reported that Christopher Mahon named the creek Clover Creek after the tall wild clover that grew along the banks. But how did Elizabeth get to Puget Sound country before the stream of travelers started to trickle in, and for that matter, how did her tablecloth get into the Prairie House Museum?

Here's what we know: It's true that Elizabeth Mahon fed weary travelers as they stumbled in, exhausted and hungry at the end of the Oregon Trail. The tablecloth she spread on her table to welcome the travelers is on display at the Prairie House Museum, but who was she, and how did it happen that she was there waiting to welcome them with real Northwest hospitality?

If you visit a home anywhere from Bonney Lake to Yelm, chances are good that at some point, your host will gesture toward the backyard and say, "You know, the Oregon Trail ended right there." And there's a good chance they're right. The Oregon Trail splintered once it crossed the Columbia

Mrs. Mahon's tablecloth and typical china, which withstood the hazardous trip. *Prairie House Museum, Spanaway, Washington.*

River into the new Washington Territory (still Oregon Territory in those days). With many wagons lost, broken and repaired and only a fraction of the original pioneers remaining, they had survived the perilous descent, one wagon at a time, down steep mountainsides, only to risk drowning in the rapids of rushing rivers. Those who survived were flinty in their resolve to claim a life of their own in the new land. A story was told with relish of a pioneer widow—newly made—who when told that her husband had been lost in that perilous descent said rather cavalierly, "Plenty more where he came from."

Of course, everyone loves a historical mystery, so I enlisted the aid of experts who have studied this era. Here is what we know about the Mahons: Christopher Mahon married Elizabeth on January 9, 1846, in New York City. He was twenty-four and worked as a waiter, but by September 18, 1847, he had enlisted in the army. In 1849, the young couple was in New York when their first son, William, was born. Christopher may have been on leave after serving in the Mexican-American War, which ended in 1848.

So Christopher Mahon's journey is easy to trace, but none of this explained how Elizabeth and their boy William got to the Puget Sound. Even today, spouses cannot always travel with their military sponsors. The team of sleuths who worked on this story and I speculated that Elizabeth almost certainly didn't travel with her husband on the ship that brought the troops in. High-ranking officers might have the privilege of traveling with their spouses, but Christopher's rank of private would have barely entitled him to travel with a duffel bag of personal belongings. It seems equally unlikely that Elizabeth would have made the difficult Oregon Trail crossing alone. Writers are just beginning to touch on the fact that the trip across country was much harder for women that men—and all but impossible for single women. Utah historian Juanita Brooks described her grandmother's narrative: "When a [wagon] train set out, the captain made a rule: women to one side, men to the other. Where flat and barren terrain made privacy seem impossible, women would band together and spread their long, broad skirts to form a screen."

One can only imagine how impossible the journey would be for a woman alone or with a small child. That was what we speculated, and as is often the case with amateur history detectives, we were wrong.

Almost immediately after the baby's birth, the new father was sent to the Oregon Territory, where his name appears on the roster of soldiers. He was sent to the Northwest in 1849 with the First Artillery, under Captain Bennett H. Hill. The First Artillery, according to some reports, sailed around

the horn of South America on the steamer *Massachusetts* and landed first at Vancouver. Joan Curtis of the Steilacoom Historical Society provided the definitive word from the John Rigney history:

> *In 1848 John and Elizabeth Rigney sailed with other Irish Catholic soldiers and their wives on the steamship Massachusetts bound for Fort Vancouver. They arrived in April, 1849, after a six-month trip by way of Cape Horn. The next summer, Companies "M" and "L" were ordered to Puget Sound to protect the settlers from the Indians. The two companies sailed north on the sloop* Harpooner [and] *arrived at the mouth of Chambers Creek.*

It is presumed that the Mahons were on the same ship, writes Joan. Not too surprisingly, the officers arrived separately on a chartered barque:

> *August 23-25, 1849: About dusk Captain Hill of the U. S. Artillery accompanied several of the officers of his company (M) arrived from the chartered barque* Harpooner. *They had come up from Vancouver and were looking for a site for winter quarters. Hill was accompanied by Major Hathaway.*
>
> From The Journal of Occurrences at Fort Nisqually,
> *May 30, 1833–September 27, 1859.*

Fort Steilacoom was very important, built first to claim the land and to protect local settlers, but it soon acquired lasting importance. It was used as a base while soldiers pushed out from the fort to build roads that would cross the Northwest and be used into the twenty-first century.

Karen Meador is a Northwest author, historian and speaker whose presentation "All Roads Led to Fort Steilacoom: The History of the Fort Steilacoom to Fort Bellingham Military Road," can be counted on to draw enthusiastic crowds. She points out that "the first military roads in Washington Territory were the Fort Steilacoom to Fort Walla Walla Road and the Fort Vancouver to Fort Steilacoom Road." Today's I-5 still roughly follows that same original route to Vancouver, Washington This was especially impressive in light of the fact that most of the work was done by a single person, U.S. Army captain W.W. DeLacey, according to Meador: "Based at Fort Steilacoom and traveling by foot, he surveyed the wilderness accompanied by Native Americans and settlers. He was guided by a pocket compass and used an ax to mark trees along the route."

This is included to underscore how extremely difficult movement was at that time. It's amazing that same route is still in use and heavily traveled under today's heavy traffic.

There remains another possibility—that Elizabeth Mahon and some of the other wives sailed to Fort Steilacoom on a different ship, probably on the *Beaver*, that sturdy and unique little ship that plied the waters from the west coast of Canada to Puget Sound, bringing passengers, livestock and supplies.

In any case, the 1860 Washington Territory census lists a "Mister Mahon." He was a private in the army at Old Fort Steilacoom. Of course, the records make no mention of a Mrs. Mahon, because in those days, the saying was, "If the army wanted you to have a wife, you'd be issued one." They weren't kidding.

So when the personnel first arrived, the army took over the old Joseph Heath farm on land leased from the Hudson's Bay Company. The officers slept in the house. The enlisted men slept in the barn, which was natural. The

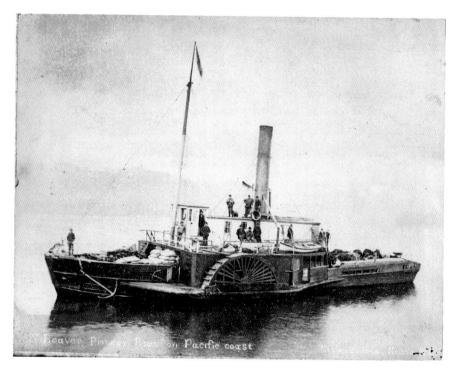

The *Beaver*, first steamship to visit Puget Sound, carried passengers, supplies, even sheep and cattle. *State Library Phot969.4ograph Collection, 1851–1990, Washington State Archives, Digital Archives.*

Fort Steilacoom was an important presence on the Puget Sound. *Historic Fort Steilacoom, Steilacoom Washington.*

first shelters built were log structures, but the permanent quarters (army-speak for houses) remain today. For a century, military housing was all built on the same plan, so whether you were at Fort Steilacoom or Astoria, they'd all be the same. The Mahons wouldn't have occupied one of the homes that remain today on the grounds of Old Fort Steilacoom.

One way or another, Elizabeth Mahon was able to join Christopher at Fort Steilacoom. Every army wife who has shared her husband's assignment in a strange country will know what it was to arrive in a new land alone. This new land was darkly forested and largely unpopulated.

Elizabeth Mahon may have found work as a laundress at the fort. There were small houses—huts really—across today's Steilacoom Boulevard, where Fort Steilacoom Park is today, and the laundresses lived there. Occasionally, their husbands could come and stay with them. We can't be sure, because the activities of women just weren't accurately recorded. But Elizabeth wrote about how much she hated doing Colonel Casey's laundry. She thought his standards were well beyond reasonable, shooting past exacting and into the ridiculous.

The couple, along with two other families from the fort, those of Friederick Meyer and Henry Jahn, filed neighboring donation claims in what is now

Right: Colonel Silas T. Casey, first commander at Fort Steilacoom. As brigadier general, Silas fought well at the Battle of Seven Pines in the Civil War. *Library of Congress*.

Below: The first squat log structures built at Fort Steilacoom. Sketch by William Burch McMurtrie. *Historic Fort Steilacoom, Steilacoom, Washington*.

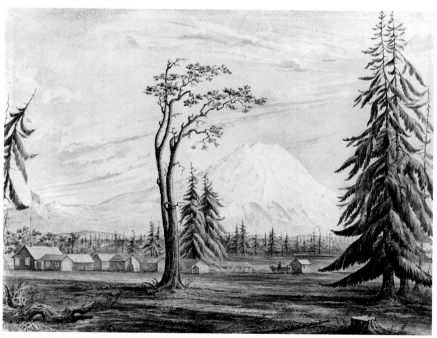

Spanaway. The trio had served together in the First Artillery Regiment in the Mexican-American War, and after service at Fort Vancouver, they were part of the troop that established and reinforced Fort Steilacoom.

Jean Sensel, author of Arcadia Press's Images of America: *Spanaway*, relates their story:

> It was so difficult to get to the interior of the south Puget Sound region that virtually the only people to take advantage of the 1850 Donation Claim Act were either Fort Steilacoom soldiers, like Meyer, Jahn, Mahon and others, or Hudson Bay Company men like John Montgomery.
>
> The Mahons did not have to have money to buy their homestead. Per the 1850 Donation Land Act, they only had to work the land for four years by December 1, 1850, and erect an 18 by 24 building to acquire 320 acres, 160 for him and 160 for his wife. The Mahons, like the other 1850 settlers in this region, were actually illegal squatters on land legally recognized by a treaty between the U.S. Government and Great Britain to belong to the Hudson Bay Company.

I was reminded that Elizabeth Mahon was not the only one to offer hospitality to newcomers. This isn't surprising, because the Northwest has always been a land where "you do it for somebody else." But because I've moved on military orders, down long lonesome roads, and I've been a stranger relying on the kindness of strangers, Mrs. Mahon's Tablecloth represents the spirit of the Northwest—and of army wives—in many ways.

Mrs. Mahon was not the first hostess to provide aid and succor to later arrivals. John Longmire wrote that Dr. William Fraser Tolmie of the Hudson's Bay Company sent a wagon full of beef to the starving members of his train, as did John Montgomery, also a Hudson's Bay Company man who was Spanaway's first white settler, and his wife, who was a Native American. (Author's note. When I first wrote about Dr. Tolmie's kindness, I transcribed the entry to read "He sent a wagon full of beer and everyone felt much better." This seemed quite reasonable to me, and it was quite a while until I noticed my mistake.) But their tablecloths aren't exhibited in the Prairie House Museum, silently inviting us to salute their hospitality. I mentioned at the beginning of this chapter that the tablecloth on display is tattered and has pieces missing from it. That is because hunters and soldiers, not knowing what it was, ripped off pieces of the nice, soft material to clean their rifles.

There are always surprises when you research stories like this—and one happy surprise is that Elizabeth and Christopher turned out to be the

Elizabeth Mahon, December 23, 1820–September 29, 1909. *From* My Home Town, *"Parkland."*

great-great-grandparents of one of Tacoma's most prominent mayors and community activists, Karen Vialle, who says that the family records show that Christopher came here with the army on a troop ship. Elizabeth did indeed make her living as a laundress for the troops, Vialle went on, and she didn't like it. She particularly didn't like doing laundry for the officers.

And that leaves only the story that Elizabeth Mahon is buried on the Brookdale Golf Course in Tacoma. Like so many other legends and stories, that's close, but not accurate. She is actually buried in the Mahon Family Cemetery, which is on private land very, very close to the golf course. The only access to the cemetery is, with permission, through a gate in the homeowner's backyard. It does look as if it's on the golf course, but it isn't. However, the members of the Brookdale Golf Course have certainly taken her into their hearts. It's a rare treat to be able to golf and retrace history at the same time. Here are notes from a recent newsletter, connecting the course to its historical antecedents and inviting members to be aware as they golf of what activities once happened at each hole. From the Brookdale Golf Course newsletter, October 2016:

> *On hole 4, just as the fairway bends to the left you will see on your right on a slight ridge just wide enough for a horse drawn wagon to pass. This is said to be the path of covered wagons on the Naches Trail.*
>
> *When you play hole seven with the course sheds to the west, the Mahon homestead was probably located between the fruit trees on the high side of the creek. Easily visible behind the green on 13 is a small pioneer cemetery where Christopher and Elizabeth Mahon and others of the family are buried. The stone placed above Elizabeth Mahon reads:*
>
> *Mahon, Elizabeth 12/23/1820–09/29/1909*
> *Dearest mother thou hast left us. Here thy loss we deeply feel,*
> *But tis God that hath bereft us, He can all our sorrows heal.*

When you look at the picture of Mrs. Mahon, she seems severe, yet there is her black formal umbrella at her side. That is not an ornamental sun parasol; that's a sturdy rain repellent accessory. She is a Pacific Northwesterner and prepared for anything. One change Elizabeth Mahon would see today is that Pacific Northwest residents, stubbornly and proudly, almost never carry umbrellas. We know it rains here, but we don't care. We're preshrunk.

6

OLD FORT STEILACOOM: THE LITTLE CHURCH THAT COULD (AND STILL CAN!)

THE STORY THEY TELL

Immaculate Conception Church, now located overlooking Puget Sound in Steilacoom, was originally built on the grounds of Old Fort Steilacoom. It was so beloved by the parishioners—soldiers and local families—that when they learned the fort was to be closed, the church was actually taken apart and moved in sections to its present location in Steilacoom. When Fort Steilacoom closed, the soldiers found they'd built something too precious to lose. What happened next is heartwarming and faith-affirming.

THE REST OF THE STORY

One thing that's been true of army installations since the very beginning is that one post is much like another; even the feel of the gravel beneath your feet is the same everywhere. That's true across the country and across time. Old Fort Steilacoom was an important post. It was the first American military presence on Puget Sound, and Old Military Road, which the soldiers built, is still there and well traveled today. In fact, a traveler to Parkland and Spanaway can walk across Old Military Road to the place where travelers over the Naches Trail first set foot in Puget Sound Country. Because of the

vast open spaces still remaining in Puget Sound country, it's amazing how easy it is to walk into history.

The U.S. Army came to the Puget Sound in May 1849, led by Captain Bennet Hill. A company of twenty-three men, complete with a bugler, essential to the good order of the camp, reached the location in August. Company M had arrived. The troops had come to stabilize the area, protect citizens of the growing neighboring communities and, of course, seize the chance to create an American outpost on what had been British land. They rented one square mile of farmland from the Puget Sound Agricultural Company for fifty dollars a month. According to a chronological history prepared by the Historic Fort Steilacoom Association, the barns were first used as barracks and the farmhouse was used as quarters for the officers. The army served as a stabilizing presence, but in general, the Native Americans in this area simply weren't aggressive. Dr. Francisco Juarez, Bonney Lake physician and historian, maintained that the Indians were prepared to peacefully share the land, but they could not understand the fences. They believed that the land belonged to God and no one had the right to fence it. This, he believed, was the source of the hostility that occurred.

With the U.S. Army on the scene, it was a signal that Uncle Sam decreed Washington Territory ready to grow. In 1857, crews set to work on the permanent installation. Temporary log buildings were erected as the first fort. Military posts are built to specifications, and generally, the buildings and posts are nearly identical. Even today, a stranger can find his way about on an unfamiliar post just by having visited another. As was customary, too, an all-purpose, all-faith chapel was built—and built to last. At Fort Steilacoom, that chapel is still used in one of the surviving buildings. The all-purpose chapels had their limitations, though, the altar for Protestant services had to be transformed for Mass while worshipers waited.

Most of the soldiers were Irish immigrants who longed for a real Catholic church where one could stop in to make a visit and say a quick prayer at any time. So they built one with their own hands on their own time. Folks from the surrounding areas soon joined the soldiers at Mass. The little white church, called the Church of the Immaculate Conception, became a community fixture.

But back to Fort Steilacoom and the four remaining buildings that you can visit today. Walk into Colonel Silas Casey's quarters, and it feels like so many quarters everywhere. Some of us from what you'd call the "old army" are protective of the original army housing designations. Sounds ridiculous, but there it is. I find myself correcting someone who has the temerity to say

Carpenters were still at work when the inspector general visited the fort. *Historic Fort Steilacoom, Steilacoom, Washington.*

Army "camped out" in farm buildings before the fort was built. *Historic Fort Steilacoom, Steilacoom, Washington.*

Catholic church, Nisqually and Main Streets, Steilacoom, Pierce County, Washington. *Library of Congress.*

that was Colonel Casey's house. No. Colonels don't live in houses. Those were his quarters.

When Fort Steilacoom was created, it was in Oregon Territory, but Congress divided the land to create Washington Territory in 1853 and now the post stood in this new territory.

There's one feature that's absolutely unique to old Fort Steilacoom. There are few parade fields in the world with anything like the beautiful view of Mount Rainier dominating the skyline.

In 1857, Lieutenant A.V. Kautz was authorized to construct new buildings on the site of Fort Steilacoom. The good news was that he was authorized to erect those new buildings. The bad news was that it was to be done according to quartermaster specifications. Nothing could be done until the funds turned

up, and that would take quite awhile. In its wisdom, the government decreed that all government quarters, wherever the sun shone on a U.S. Army post, should be identical. Certainly that would apply to this scruffy Northwest fort that nobody had ever heard of or ever wanted to. Still, for an old army wife like me, walking into Colonel Casey's quarters—or into any other vintage officer's quarters in the USA—feels like coming home. It wouldn't be until 1949 that the design of military quarters would change with the addition of Wherry housing, designed to allow low-cost housing for military families.

Lieutenant Kautz used army quartermaster specs. When the construction finally got going, it went fast. It was easy for them with the local materials and labor. They made their own bricks. There were local blacksmiths. Carpenters milled the local wood and soldiers helped put the buildings up, according to Synthia Santos, who was the Lewis Army Museum historian for nineteen years. According to the Historical Fort Steilacoom Chronological History: "In his annual report (June 1858) Lt. Kautz stated that the CO's Quarters and the Commissary Store, Clothing Store and Soldiers Barracks were complete." Only four of the twenty-five buildings erected remain today.

In December 1985, Colonel Joseph Mansfield, the inspector general, visited the fort. His report indicated that he was impressed with the arrangement of the post—which is the impression you strive for when the inspector general is coming. He reported that ten carpenters were still at work, most of the buildings were new and three companies were properly quartered.

One of the most important achievements of the soldiers at Fort Steilacoom was to begin construction on the Military Road, which started at old Fort Steilacoom and continued on all the way to Bellingham near the Canadian border. It would continue to be a defining landmark of the area into the twenty-first century.

Life on a military post in the 1800s was much like life in any small town—in the Middle Ages. Rank and position were sharply delineated. Inside Fort Steilacoom were the accouterments familiar to anyone in the army life.

Duane Colt Denfield, PhD, wrote an essay that explains the situation the Fort Steilacoom troops found themselves in next. It is quoted here in part:

> In 1859 troops from Fort Steilacoom went to the San Juan Islands to protect United States claims. With the beginning of the Civil War, the U.S. Army troops were needed in the East and were transferred east. Volunteer units formed in the West came to occupy Fort Steilacoom. The units included companies G and K of the 1st Washington Infantry Regiment

Old Fort Steilacoom, alone on the prairie—one of the buildings still standing. © *Steilacoom Historical Museum Association.*

rounded out with troops from the 1st Oregon Regiment and Company E, 4th California Infantry Regiment.

They lacked the discipline that had characterized the regular army and many of the troops found themselves in trouble. Among their duties were maintaining the peace and construction of roads and communications. Even before the end of the Civil War, it became difficult to retain volunteers at the fort. With the Confederate surrender, the remaining volunteers were sent home. A regular army force, the 14th Infantry Regiment came to the post, but had a limited role. The army had started closing posts and Fort Steilacoom was unneeded.

Colonel Casey left Washington in 1861 and went East. He was promoted to brigadier general and led a division during the Civil War Peninsula Campaign. On May 31, 1862, at the Battle of Seven Pines he fought troops that were under the command of Confederate Brigadier General George Pickett (1825–1875). Soon after this battle Casey was promoted to major general. Interestingly, Pickett, while a U.S. Army officer had in 1856, commanded D Company, 9th Infantry Regiment, in Washington. One of Casey's major achievements was publication of infantry training manuals that were used by both sides. One son, Thomas Lincoln Casey (1831–1896) became Chief of Engineers. The coastal defense post Fort Casey was named in his honor in 1900. This Whidbey Island fort closed in 1950 and became a State Park in 1956.

By the 1860s, rumors were beginning to float that Fort Steilacoom would soon be deactivated, which made sense, as the installation was just finished and paid for. In 1863, the Sisters of Providence asked that the little white church be moved from the fort into Steilacoom. This idea was initially met with skepticism, but those skeptics clearly did not know the Sisters of Providence, who had already built a school and convent in the town of Steilacoom. They reasoned a church would be needed in this fast-growing town, and it would surely fall to ruin if it was left on the old fort. Of course, the soldiers and townspeople were anxious for their church to be saved. The legend is that the church was moved board by board, but in fact, the little church was actually divided into five or six parts and transported by wagon into Steilacoom and placed next to the residence of the sisters. I've spent a lot of time trying to work out how it was divided. The picture of the church at the fort shows that it was configured quite differently than it is now, though the steeple tower on today's church is visible. But they did it.

On April 23, 1864, the *Puget Sound Herald* carried the following notice: "Under the direction of Reverend Father Vary, the work on the new Catholic church is steadily progressing. It will probably be finished in two months from this date." On June 26, 1864, the little church in Steilacoom was consecrated by the famous Bishop Blanchet, the bishop of Nisqually.

Church of the Immaculate Conception, Steilacoom. © *Steilacoom Historical Museum Association.*

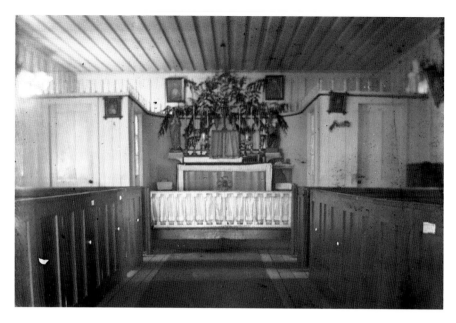

Church of the Immaculate Conception, interior. © *Steilacoom Historical Museum Association.*

The church is active to this day, perched on the same hill, with a heart-stopping view of Puget Sound as worshipers come out the door. It is easy to see that our predecessors must have been smaller people. The seats in the pew are narrow, wooden and very hard—the same ones built by the soldiers. The seating capacity is sixty, but on Sundays, it's standing room only. And worshipers are rewarded with one of the most panoramic views of Puget Sound imaginable. Today, on an average Sunday for 7:30 a.m. Mass, the little church is filled with local residents, soldiers from nearby Joint Base Lewis McChord, retired military personnel and generals. Lots of generals. There is a wonderful feeling of history. The church has come full circle.

The Historic Fort Steilacoom newsletter noted that two Sisters of Providence, a lay helper and an orphan left Vancouver for Steilacoom, going by way of Victoria and arriving at Steilacoom on November 25, 1863. They purchased a piece of land two hundred feet square for the total sum of one dollar. On this land, they built a two-story frame building twenty-four by thirty-two feet. That became the base of the school.

There was always a shortage of money, and the pastor was frequently away for long periods of time. At one point, the sisters held a Christmas bazaar that brought in $330 for interest and necessary expenses.

Fort Steilacoom was closed in 1868, and in 1871, Washington Territory purchased the fort with the intent of turning it into a hospital for the insane. The new hospital, called the Insane Asylum of Washington Territory, opened in 1871 with fifteen men and six women patients, according to the Washington State Department of Social and Health Services. The hospital stands today in full use, and in fact, by act of Congress, the land cannot be used for any other purpose. However, the farm and orchards where patients once worked as part of their "therapy" has been converted to a beautiful park.

The pastor most associated with the little church is the legendary Father Louis Rossi, a Belgian priest who was the first to celebrate Mass at the church and continued to do so for two years. In 1856, Father Rossi arrived in Vancouver, Washington, by ship from San Francisco. He was in poor health, which nagged him all of his life. The church was still at the fort then and not moved until about 1864. It isn't mentioned in his book when he was first assigned to mentor the Church of the Immaculate Conception.

Living History performer Ray Eagan, who devoted many years to re-creating and interpreting the life of this great man, recalled that Father Rossi baptized five hundred Native American children. Eagan believes that Rossi's finest quality was his ability to just let people be.

There were never enough priests to serve all of the people in the Puget Sound. The area was divided up so that Father Blanchette had Fort Vancouver up to the Cowlitz River. Father Rossi had the area from the sound to the English border and from the Cascades to the Pacific, a sizeable parish.

Ray Egan spent years absorbing the life and character of Father Rossi. Father Rossi is revered in the Puget Sound country but arrived here with a very checkered past. Egan characterizes him as a seminarian in a very strict order of missionary priests known as the Passionists. In a matter of months, Rossi was asked to leave, and the documents pertaining to his dismissal record denounce him as "petulant and choleric." "Perhaps his threat to strike his novice master with a large altar candle had something to do with it," Eagan reflected.

Nevertheless, Father Rossi was reaccepted and in April 1843, at the age of 27, was ordained a Passionist priest. After teaching rhetoric and philosophy for several years, Rossi spent six months learning to speak French and in January 1855 was selected to be the superior of a Passionist community in Bordeaux, France. Almost immediately, it appears, interpersonal problems erupted and in October Rossi was asked to resign his position. Perhaps

in a display of petulance and choler, he opted instead to resign from the Passionist order and became a secular priest.

Coming to the new world, Father Rossi recruited six nuns. The group included Mother Joseph and one almost wonders what Father Rossi could have accomplished if he'd felt well because poor health dogged him his whole life. Upon arrival at Fort Vancouver in December 1856, he was immediately put to work learning English. In November 1857 Blanchet assigned him to minister to the 300 Catholics in an area which ranged from the Cowlitz River on the south to the Canadian border and from the Cascade Mountains to the Pacific. This would include Steilacoom and he became the first priest to celebrate Mass at the new location of the little white church.

It may be just as well that Rossi's responsibilities did not include the Indians, as his Eurocentrist sense of superiority towards these "sauvages" conflicted with his spiritual obligation to treat all men equally as children of God. He did however think more highly of the Indians in California and elsewhere a number of whom had learned to read and write in mission schools. To him, the ability to read and write were measures of intelligence.

MINISTERING TO FORT STEILACOOM

From Ray Eagan:

Rossi selected Fort Steilacoom as the base for his ministry because of the large number of Irish and German Catholics found among the soldiers and also because of that church they had built in the middle of the fort. Another motive may well have been the presence of the army doctor, who could treat him for his frequent bouts of severe pain in the abdomen, chest, and joints. It is likely that Rossi was afflicted with Mediterranean Familial Fever, an inherited disorder to which Sephardic Jews are particularly prone. The malady manifests itself in recurrent severe stomach cramps and chest and joint pains, accompanied by a high fever. Rossi was twice subjected to operations in an apparent attempt to cure him: first by the heavy-drinking surgeon at Fort Steilacoom, who may have removed his appendix, and then by a father-son team of physicians in San Francisco, who possibly removed his gall bladder. They offered to show him what they had extracted but he, understandably, declined.

As there were virtually no roads and few passable trails, Rossi made the rounds of his missionary district occasionally on horseback but mostly in Indian canoes and on the several paddle and screw steamers that plied the Sound. He was constantly on the move and became a familiar and recognizable sight in his black robe and wide European hat. His ministrations were available to Catholic and Protestant alike and he noted—with modest self-satisfaction—that the latter typically made up half or more of his congregations and audiences and accounted for a commensurate portion of the funds put in the collection plate.

Mills and camps rushed into existence by the demand for lumber from California's gold fields offered fruitful opportunities for his ministry and by Rossi's count he visited some two dozen of them scattered in isolated nooks and crannies from Olympia to Port Townsend. On a visit to Seattle in July 1858 he lodged in the infamous Felker House hotel run by Mary Conklin (1821-1873), known locally as Mother Damnable for her foul tongue and bullying ways. In her drawing room he preached a sermon to an audience that remained silent when he exhorted them to join him in prayer because, as he learned later, there were no Catholics in the room. And apparently, on that occasion at least, there was none in the entire village.

Father Rossi's health never improved, and he returned to Europe in 1862. He had spent three years in Washington Territory and three more years in California and left an indelible impact.

The Church of the Immaculate Conception was added to the National Register of Historic Places in 1974.

But in the Puget Sound, the spirit of Father Rossi is never far away. On one occasion, a busload of tourists came to see the little church in Steilacoom where Ray Eagan was waiting to greet them in his role of Father Rossi. For an hour he held us all spellbound, as, portraying the man as he must have been in his church, he spoke of the accomplishments, dreams and sorrows of his life in the New World. After the presentation was over, an elderly man came up to me and said, "Did you say Father Rossi came here more than a hundred years ago." Yes, I nodded wordlessly. The gentleman brought his mouth close to my ear, and whispered, "Well, he's still here." Yes, we think so too.

The Territory Grows

7

Orting: Reclaiming the Dark Tower

The Story They Told

This tower stood in the midst of Orting for as long as anyone could remember. Apparently, nobody knew what it was for sure. Some thought it was a granary, and some thought it belonged to one of the old sawmills, but whatever it was, it was due to be torn down. Then the residents rebelled. "I don't know what it is," said one, "but I know it's history!" Well, the city didn't tear it down. It's there today. What happened, and what purpose does it serve?

The Rest of the Story

The day our TV crew arrived in Orting to shoot *My Home Town* in November 2006, Orting was dealing with the worst flood threat in memory, but neighbors looked out for one another as neighbors always do, and the Orting High School marching band, splendid in red and black uniforms, turned out to escort us smartly through town to the accompaniment of college fight songs. Of course, we heard about the mysterious tower and actually happened to arrive there on the day that the City of Orting had sent a backhoe out to knock down the tower—whatever it was.

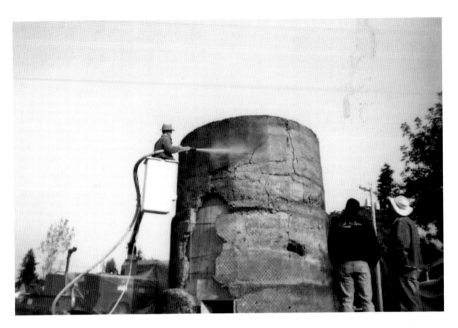

The face-lift begins for the mysterious Stephenson-Coe Tower. *Photo by Guy S. Colorossi.*

A neighbor took one horrified look, gathered her children and marched them out to the tower. "You can't tear it down," she announced to the driver of the backhoe. "It's part of history! It's been there this long and it has to stay." As Delcy (DiAnn) Harvey of the Orting Historical Society recalled the encounter, "We saw about nine men standing around it and they were planning on just tearing it down." Harvey and her children arranged themselves next to the tower, daring the earth-moving equipment to come forward even a foot. The equipment didn't move, and the victorious citizen activist made her feelings crystal clear, "You can't just tear it down! This has been here longer than you or I. This is history!!"

She continued, "We went to the historical society and came up with some different ideas. One of the ideas, a favorite one that I have, is that I would like a mural painted on it. And I would like to put on it, 'History you can touch!'"

Longtime mayor and charter member of the Orting Historical Society Sam Colorossi recalled, "DiAnn called me that very day and said, 'Sam, we have to do something to save the tower!'"

Victorious for the day at least, DiAnn Harvey sent her children off to school. The television van packed up our camera and crew, and as it often

happens, we never knew how the story came out until recently, when I was delighted to hear that the City of Orting had decided to save the tower and indeed had devoted more than $12,000 to restore the structure and make it a permanent part of the park near the Foothills Trail. That's a substantial commitment from a town so small that residents have been watching the annual Daffodil Parade from their front porches since the 1950s. It was easy to fill in the story of the historical tower.

The tower was originally a sawdust burner belonging to the Stevenson-Coe Lumber Company from the days when the lumber industry was king in this part of the Puget Sound.

Now it was the idea that caught fire, and Sam Colorossi threw himself into the effort to save the tower. Sam is grandson of one of the early settlers of Orting. His grandparents arrived from Italy in 1913. Sam recalled, "My grandfather Salvatore Colarossi came from the City of Pacentro, Italy. He arrived in this country in 1913 at the age of twenty-two. His name was changed to Salvatore 'Sam' Colorossi when he became a citizen. The change in the last name happened due to poor penmanship." Sam was mayor of his hometown for nearly twenty years, far longer than anyone else. As of this writing, he has served more than nine years on the city council. He enjoys the honor of having been declared "Citizen of the Century," and Pierce County declared a "Guy S. Colorossi Day," both in 2014. (Sam carries his father's name, "Guy," and uses it instead of Sam on formal occasions)

So it was natural that Sam would take over the tower project, but it wasn't an easy sell. Sam recalled, "The engineer we consulted said, 'There's no way you can do it.' He said it over and over," Sam recalled, so naturally, being equal to the challenge as a historian and Orting Historical Society member, Sam Colorossi crafted the proposal that won the historical society and ultimately the city over to the idea of restoring what came to be called the Stephenson-Coe Silo. Orting has a history shared by many small Puget Sound towns. The first settlers were part of a wagon train that crossed the Cascades at Naches Pass. Orting, created in 1889, was first named Carbon for its place on the Carbon River, but the name was changed to Orting, meaning "Town on the Prairie."

Having a grasp of history seems important to the citizens of Orting. In the fast-moving West, cities, buildings and industries grew and disappeared. Historian and Orting History Society founder Alice Rushton is fondly remembered for urging members to remember, "We need to take care of history." And they've done well. Sam Colorossi recalls creating a bell tower to commemorate the city's centennial on land the city didn't yet own and

paying for it by selling bricks engraved with patrons' names for $18 apiece. For this small town that had a population just slightly above 2,000, there are 1,100 names on the bell tower, which proudly dominates Train Street—but this is the story of that mysterious Stevenson-Coe tower. This was a lumber town. On May 29, 1909, John R. Stevenson and Chas A. Coe jointly came together to file articles of incorporation for the new business. Capital stock in the amount of $4,000 was raised, and a certificate was issued by the State of Washington.

The *Orting Oracle* reported that the mill began active operation on February 4, 1910, even though it experienced several setbacks because of severe weather that shut the mill down.

By March 18, 1910, the mill was up and running, with shipments of clear, knot-free timber going all the way to China. Business was so good, they were turning away orders. It is not generally known that China provided a huge market for wood from the Northwest, as building materials were hard to find in China.

So often, settlements that sprang to life and flourished came to the end of profitability and nearly disappeared. That was nearly the fate of Orting. Sam Colorossi, now seventy-nine years old, recalled how the bustling lumber company was gone by the time he was twelve, destroyed by a fire that burned, "all of the buildings except a short stub that they used to bring in a railcar full of coal."

The historical importance of the Stevenson-Coe Lumber Company was firmly established, but now, with pages of supportive community members standing behind them, it was time to get started on the repair work, from power-washing, installing rebar and filling in cracks with epoxy. Why do we care? Because this is a touch of history.

The city got behind the idea of reclaiming the Stevenson-Coe silo and adopted "History You Can Touch," DiAnn Harvey's suggested theme. Linda Petchnik was chosen to paint the murals. Well known for both her murals and her lovely flower graphic prints, Petchnik had already completed two murals in Orting.

She spent many hours on scaffolding carefully rendering railhead operations such as unloading logs on trains. At the bottom of the mural is a caption:

In 1910, when the population of Orting was 799, Howard Taft was President. Boy Scouts of America was founded, and Glacier National Park was established, the Stevenson-Coe Lumber Co. began processing lumber headed for China. The concrete structure was the sawdust burner that was

Linda Petchnik at work on the historical murals that illustrate the history of Orting. *Photo by Guy S. Colorossi.*

> *located on the east end of the lumber mill* [at right on mural]. *The Pacific Northwest Railroad track was located where the Foothills Rails to Trails is now located. The mill itself sat where the fire and police stations are now located. Note the Frederick Eldredge Mansion* [left of mill] *and John Stevenson's favorite white mare. Mural painted by Linda Petchnick in 2008 and dedicated by the artist to Sam Colorossi.*

Just recently, the Pacific Northwest weather took hold of the Stevenson-Coe Silo, and the beautiful mural was destroyed. Linda Petchnik undertook to paint it again, and this time, the murals have been framed in an impervious outdoor material. Like the people of Orting, they're here for the long haul.

When DiAnn Harvey's brother Sam Webster spoke to us on that 2006 trip to Orting, he explained why he was in favor of saving the silo. "My own feeling," Sam said, "is that you can't go the right way if you don't know where you've been."

DiAnn Harvey passed away in 2014, so she wasn't able to enjoy the end of the project, but her name is close to the top of the list with

Because the beautiful murals were being ruined by the elements, they're placed in this permanent display—saving mural and tower. *Photo by Guy S. Colorossi.*

hundreds of other supporters who brought the dead tower to life. Also on the grounds near the Stevenson-Coe Burner is a living apple tree that DiAnn asked Sam Colorossi to save—so it's fair to say that Orting is a city that cherishes the past and looks forward to the future. As DiAnn Harvey would say, "It's history you can touch."

PARKLAND: GIVE US A VOTE AND WE WILL COOK

THE STORY THEY TELL

The women of Washington Territory were among the very first in the nation to have the right to vote, receiving it in 1883. They lost it in 1888, before Washington even joined the Union. Dispirited, they didn't try again for nearly a quarter of a century.

THE REST OF THE STORY

This was the way a Pacific Northwest politician, C.H. Bailey, summed up the election of November 1911, when Washington women won back the vote that many felt had been stolen from them in 1886: "The women paid no attention whatever to the newspapers, to campaign literature or to what our workers said to them. They went out, studied the situation for themselves and voted as they damned pleased. The old-line politician is as dead as a doornail. The women have revolutionized politics."

Suffrage activist Emma Smith DeVoe saw it in much simpler terms. "What is politics?" she asked, "Why, it's housekeeping on a big scale. The government is in a muddle, because it has been doing the housekeeping without the women."

Washington Territory was the fifth state where women won the full franchise vote in the 1800s. A few other states granted partial suffrage. It was a hard struggle. Donna Lucey wrote in her book *I Dwell in Possibility: Women Build a Nation, 1600–1920*, "According to the enduring myth of the west, men were primary actors on this enormous stage and women somehow ruined the place."

In 1883, the legislature approved the Woman Suffrage Bill. On November 22, Governor Gordon Newell signed the act into law. The suffragists celebrated to the accompaniment of bells and guns being fired, thinking the battle was won.

Washington women voted for the first time in 1884. They voted in 1885 and then not again until 1912. It's easy to overlook how ardent and hardworking the suffragists of that day were.

Suffragist Adella M. Parker documented the fact that women first voted in Washington in 1883. They were enfranchised by the legislature of the previous year. They voted in '85 and '86. She goes on to point out that the women of British Columbia received the franchise at the same time but never lost it. Parker continued, "Although the suffrage laws have never been repealed, women's right to vote was denied by the courts in '87, '88, and '89. The Washington Territorial Supreme Court revoked the women's right to vote in 1888 and at a re-vote she was counted out by a ballot 'marked' in the printing." So when the chance to vote arose again in 1911, the women of Washington definitely weren't in a mood to putter.

Within their first month as enfranchised voters, according to C.H. Bailey, the twenty-three thousand registered women voters "fired" one mayor (politician Charles Gill), elected another and chose their own legislative body, and the women of Tacoma, on a moral issue, recalled Mayor A.V. Fawcett and appropriated to themselves the balance of power in that city.

Emma Smith DeVoe had her own ideas about how to keep voting rights for all time—and everyone paid attention to Emma Smith DeVoe. It is possible that not many people recognize her name today, yet she was one of the nation's most active and effective campaigners for women's rights. In addition, she organized the first national organization of voting women, the National Council of Women Voters. Every conversation about this woman, now widely considered the mother of suffragettes, can be expected to start with the story about how little Emma Smith attended a speech by Susan B. Anthony.

As usual, Anthony asked her signature question, "Who believes in woman's voting?" Eight-year-old Emma was first on her feet and refused to sit down.

Apparently, there was some reluctance for adults to stand while the little girl was on the floor. They coaxed her to sit down. Nevertheless, she persisted. And soon the adult women joined her. Her father told her he was proud that she was willing to stand for what she believed in. When the time came to fight for woman suffrage, she did just that. Emma did this by launching what was called a "male style" advertising campaign, but in a feminine way. She realized that if women were to get and keep the vote, they'd have to reassure men that they'd still be cared for. This was necessitated by the stark fact that a great deal of the reason given when the vote was wrenched away in 1888 was the general (male) view, repeated constantly in press and gatherings, that there was something wrong, even unwomanly, with a woman who wanted the vote. They purported that allowing women to be out in the world in this way would be a blow—perhaps fatal—to all of the feminine values, "thus destroying hearth and home."

Emma Smith DeVoe faced this attitude with a practical good cheer that seems totally characteristic and absolutely astonishing. Her ten-point Suffragette Campaign Guidelines conclude, "Always be good natured and cheerful."

The Homesteader Life was unbearably hard, and women wanted to share the decision making. *Library of Congress, Prints & Photographs Division.*

In January 1880, Emma Smith married Henry DeVoe. Family stories say that it was a strong relationship, and Jim Welch, one of Emma's descendants, noted, "Henry was really ahead of his time in his feelings for Emma. Not only was she the love of his life, but he fully supported her work in the suffrage movement." With contributions from other women, Emma Smith DeVoe created a cookbook that combined recipes and suffragette messages. The title page was headed with the line "Give us a vote and we will cook." There was wide interest in the book. The *Tacoma News Tribune* offered seventy-five dollars for the best essay. The book combined cherished family recipes with practical directions like how to fix boiled eggs for typhoid patients. It is a reminder of how much more difficult ordinary housekeeping was that this subject came up at all. The recipes for the invalids sound so unappealing it seems a wonder anyone got better.

Because the Puget Sound is known for its variety of clams, a chapter by Mrs. Bessie I. Savage gives recipes for every conceivable way clams might be served. Only the Boring clam is inedible, Mrs. Savage informs. The Boring is a type of clam and not a critique on its character. There's even a recipe for Scrambled Clams with Eggs.

The chapter on soups begins, "The man who neglects to vote shows small interest in the welfare of his country. What shall we say of the woman who would not vote if she could?"

Support for the book and campaign came from surprising places. With iconic Mount Rainier dominating the Puget Sound skyline, it's not surprising that mountain climbing should be popular. The Mountaineers Club was founded in 1906 with a charter membership of seventy-seven women and seventy-four men. This fine organization is still active today. The Mountaineers added a chapter to the cookbook and offered a mountain climbing side trip to those who attended the Forty-First Annual National American Woman Suffrage Association convention held in Seattle in July 1909. Those who went on the climb were advised by Dr. Cora Smith Eaton on what to take along, and it amounted to forty pounds of supplies for each camper. The frail sex? Not so much. Summiting members of the organization were to plant a large Alaska-Yukon Pacific Exposition flag with a Votes for Women pennant attached to the staff at the Columbia Crest Summit, according to Paula Becker. On the day of the expedition, the climbers set out, the women wearing the following— all of the following. First, of course, an undersuit, bloomers, cotton hose with boys' wool socks pulled over for comfort, short knee-length skirt to be discarded on hard climbs, mountain boots with hobnails, mosquito head

Give us a vote and we will cook said the *Washington Women's Cookbook*. *Library of Congress, Prints & Photographs Division.*

net or bee veil, smoked goggles, heavy gauntlet gloves and then rubber poncho or slicker coat. One is filled with admiration for any woman who could stay safe, enthusiastic and upright wearing that heavy wardrobe. The climbers set off, and they did reach the summit, but Becker acknowledged that the wind snapped the staff after only fifteen minutes. However, the climbers were able to place the flag inside Columbia Crest crater and leave it there triumphantly.

The Mountaineers chapter of the cookbook tries to cover all bases. It starts with how to build a fire (always carry an inch or two length of candle in your pocket in case there's no kindling) and a list of provisions for four people for one week prepared by famed photographer Asahel Curtis.

Emma DeVoe carefully plotted her campaign. Besides the cookbook and accompanying publicity, Emma's organization produced a regular newspaper, articles and editorials written for other publications. Then there were accompanying banners, posters, pins and badges. The cookbook even contained a recipe for making paste to hang the posters.

In that media-advertising blitz, she created a combined campaign by publishing a cookbook that was both fundraiser and part game-changer.

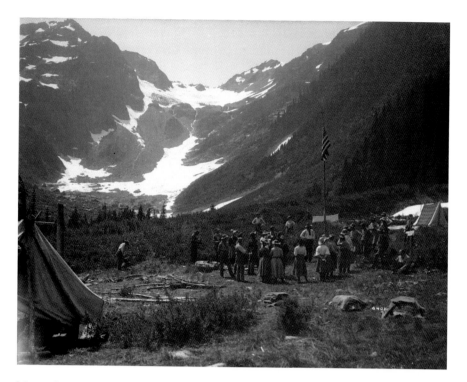

Mountaineers and Suffragettes. The Seattle Mountaineers chartered in 1906 with more women than men. The women's outfits weighed forty pounds. *University of Washington Libraries, Special Collections.*

In fact, the suffragettes did a superb job of what would today be called branding. Her campaign guidelines included, "Try to have every woman in the state asked by someone to vote for the amendment. That will carry it." This extremely popular technique is in effect at every election today, so she was well ahead of her time.

The designers of the publicity campaign seemed very aware of today's advertising maxim that the public must have five contacts with an item before they buy. In fact, Washington women distributed more than one million campaign pieces. In the final vote, the women's suffrage amendment won by a margin of almost two to one.

The response to the vote shows that Emma DeVoe was right on the slant of the cookbook. In *Women's Votes, Women's Voices,* Shanna Stevenson writes, "Newspapers generally downplayed the result women got in the victory. The PI [*Seattle Post-Intelligencer*] headlined the election, 'Women of the State Get the Ballot by Gift of Men.'"

DeVoe, remaining true to her creed of cheer, thanked the men of Washington "who by their vote gave their mothers, wives and sisters equal franchise."

In 1910, the DeVoes moved to their new country home, which they called Villa DeVoe, just outside of Tacoma. Local publications report that Henry became a gentleman farmer, raising chickens and orchard crops. Emma was rarely there because her work kept her on the road.

The DeVoe Mansion is still there today—in Parkland or Tacoma or Elmhurst. It seems to manage the remarkable feat of being in three locations at the same time, but Jean Sensel, author of IOA: *Spanaway*, asserted that in this case, the city boundaries moved. The mansion stayed in the same place. The Devoe property is in Parkland. The reason the border seems to move is because there are three different boundaries set by three different agencies, so it depends upon which one is chosen. The post office address is Tacoma. The boundary review board is Parkland. The plat maps are Elmhurst.

The DeVoe Mansion began as a humble 1800s farmhouse. In 1910, Henry and Emma Smith DeVoe purchased the farmhouse and five acres of land and began work on their dream home. They oversaw the work of enlarging and creating the beautiful 5,600-square-foot mansion that stands today.

Emma Smith DeVoe wrote this in the dedication to *Washington Women's Cookbook*:

> *To the first woman who realized that half of the human race were not getting a square deal and who had the courage to voice a protest; and also to the long line of women from that day unto this, who saw clearly, thought strongly and braved misrepresentation, ridicule, calumny and social ostracism. To bring about that millennial day when humanity shall know the blessedness of dwelling together as equals.*

Washington Women's Cookbook is still available with its combination of practical and astonishing notes. There's what seasonings a sailor should take to sea for a twelve-month voyage, for instance, and how to cook a porpoise, an appalling idea for today's cooks. The book even contains directions for building a fireless cooker, a sort of precursor of the crockpot. There's how to boil water without burning—credited to Mrs. Jennie Jewett of White Salmon, Washington, who warned that water that is burned leaves the old burnt material in the teakettle and is not fit to drink.

Emma Smith DeVoe finished her journey in Tacoma, Washington, on September 3, 1927, at the age of seventy-nine, leaving behind her a legacy of positive change and the undying gratitude of the women of Washington—whether they know it or not. "Give us a vote and we will cook, the better for a wide outlook."

University Place and Fircrest: A Short Tale of Two Cities

The Story They Tell

There's no university in University Place. The neighboring town of Fircrest is easier to explain. There are lots of fir trees there, and the streets seem to be named for universities like Harvard, Princeton and Dartmouth. Its seems evident that a university was expected, but it somehow never happened. This story is different than the others in this collection, because there isn't so much a story told but questions asked. Where's the university? What happened?

The Rest of the Story

The founders of University Place had every reason to be optimistic when they chose the name for the brand-new town they were establishing right on the brow of Puget Sound. At that time, in the early 1890s, it seemed like what a later generation would call a done deal.

The school was to be called Puget Sound University. It would be a private liberal arts college, and the four hundred acres of land in the parcel purchased for the undertaking were along Grandview Drive, the main avenue that runs north–south through this town. Visitors from the surrounding area marvel

at the breathtaking view of the Puget Sound and the islands beyond. They could visualize the edifice that would arise and the benefits that would come to the community. Of course, if it had happened that way, there wouldn't be a story, because there were already financial troubles by 1893. The groundbreaking went ahead in 1894, and though the plans for buildings were drawn, the land was lost before any of the projections could be realized.

"It took only a few years, until the early 1900's for everyone involved to realize it was just never going to happen," wrote Arne Handeland in his Images of America book *University Place*, "Much of the land was sold for back taxes. J.W. Murphy [apparently an Irish immigrant who served as Seattle city auditor] bought almost 600 acres for $1500. The University had paid $300 an acre less than 10 years earlier."

In fact, the school was built and, as the University of Puget Sound, is doing very well in North Tacoma, although the school website lists serial killer Ted Bundy as one of its prominent alumni. This may be a rich display of humor or really impressive egalitarianism. In any case, UPS is respected in the community, and the town continues to be called University Place.

There are jewels in University Place.

The spectacular Adriana Hess Wetland Park and the historic Curran Apple Orchard are worth the trip. The Curran Apple Orchard Park is a 7.33-acre apple orchard located within the city of University Place. Created as a hobby orchard in the early 1950s, today it offers residents and visitors a multitude of opportunities. The park holds more than two hundred trees with more than fifteen kinds of apples and offers a tranquil place to enjoy nature along with providing food and shelter for birds, bees, small wildlife and deer. The wonder of this little jewel is that it's possible for a family or an individual to adopt an apple tree. It's a great chance for city farmers to "own" a tree, care for it and nurture it the entire growing season, enjoying the apples when they're ripe. Special events are held in the park among the trees.

The big news these last years has been the opening in 2007 of the Chambers Bay Golf Course, which at 930 acres is one of the largest publicly owned properties in the developed Puget Sound region. Chambers Bay is a reclaimed gravel quarry transformed into what is officially called an environmentally responsible golf course and multiuse recreation hub. This was a controversial project, but it brought world recognition to University Place. There are what appear to be immense Stonehenge-like sculptures forty feet tall scattered about the grounds, but they are structures left over from the gravel mining days. Immense concrete mining relics are strategically incorporated into the design, creating an exciting contrast between the soft

green of the turf and the rough gray of the industrial structures. If the golf course itself was controversial, the walking trail that surrounds it is almost universally popular and heavily used by enthusiasts who drive great distances to enjoy the curving trail, which weaves around and through the golf course. There's a fanciful children's playground, and the whole park is situated on the shores of the Puget Sound on what had been a rock quarry for more than two hundred years, having been used by the Steilacoom Indian and the first European settlers in 1832. It may seem odd, but the quarry was a friendly and familiar site to local residents. The quarry management kept a huge supply of sand at its gates, free to anyone who wanted to fill up bags and take it home, so the huge sandbox our kids enjoyed was a beneficiary of that neighborhood friendly gesture.

The golf course itself was conceived as a pure links golf course modeled after St. Andrews in Scotland. In the interests of full disclosure, the author is not an ardent golfer. In fact, I have never golfed in my life, so I looked it up. I found that golf was played at St. Andrews for the first time in 1552 and Mary, Queen of Scots was seen playing golf as a new widow after the death of her husband, Lord Darnley, in 1567. She is the first known woman golfer. However, Jeroen Korving in *Leading Courses*, offers this description of the many qualifications a true links golf course must have. It must be alongside the sea, consist of sandy soil and have little vegetation other than tall sea grasses and gorse, a hardy low-growing evergreen plant.

Korving continues,

> *Natural terrain is used to develop the golf holes. An important reason the game of golf originated on this type of terrain was because course designers had limited resources for moving earth to shape a course. The layout of the holes is also important.*
>
> *There have to be 9 holes going out and 9 holes coming back, which Chambers Bay doesn't have. Further, Korving points out that the terrain isn't truly natural since over 100,000 truckloads of sand and dirt were removed, as the mining permit was still in effect and it was a working mine. Then the sand, dirt and gravel were returned to sculpt the course. Finally, he takes issue with the beloved Lone Tree, the iconic sentinel Douglas Fir that stands against the water. It simply shouldn't be there.*

He's not the only one who feels that way. On the night of April 29, 2008, a vandal with an axe came in from the water and cut an eight-inch-deep gash, eighteen inches long, in the tree, but with epoxy and love, the tree was

saved. No one knows how the intruder reached the tree, possibly in a small boat, and the crime remains unsolved. This is the Northwest—we hug trees; we don't cut them down.

So Korving says that Chambers Bay has many of the needed characteristics of a links course but it isn't one. In fact, he says affectionately, it's a bit weird. But Korving acknowledges that in the long run it doesn't matter. "It's suitable for golfers of any skill level yet capable of hosting major championships and events. And designer Robert Trent Jones Jr. pulled it off. It was named U.S. Open venue for 2015." The course is for walkers only; caddies are available but are optional. Motorized carts are permitted only for those with medical conditions or disabilities, and a caddie must be hired as the driver.

The Chambers Bay Golf Course was not greeted with universal approval. The reactions of a couple of players at the U.S. Open certainly made the news. Nine-time major champion Gary Player called it "the worst golf course I might've ever seen in sixty-three years as a professional golfer," and Henrik Stenson said that the greens were like "putting on broccoli."

That's certainly an expert point of view, but the people from the community who use the popular walking trails surrounding the hills above the course out of golf ball range may disagree.

Chambers Bay and the Chambers Bay Loop boast the most picturesque backdrops for getting in your steps for the day enthused blogger Sheryll Tan. "Chambers Bay is an incredible space of 930-or-so acres of shoreline, soft forest, steep-level-rolling walking/jogging trails," says Krista Osborne "The wide open spaces are great places to play ball or fly a kite," and of course, there's the LoveLock Bridge—the bridge to the beach where lovers can't resist snapping on a lock and throwing away the key to symbolize the permanence of their love. In fact, the Puget Sound area is so replete with lovers that the security fencing began to break down and the locks had to be removed and the railing redone—but they've started putting locks on the new railing now. When Puget Sounders aren't busy hugging trees, they hug each other.

FIRCREST

Fircrest is nestled so close to University Place that visitors often don't realize they've passed from UP to this picturesque town of seven thousand. The neighboring town of Fircrest fits its name. There are lots of fir trees, and

all of the streets seem to be named for educational expectations like Regent's Place. There's no university there, either. It seems evident that a university was expected somewhere in the area, but it somehow never happened. Fircrest has its own charm and is said to have more chainsaw sculptures of bear cubs popping out of tree trunks than any other Pierce County town. Writing in the *Suburban Times*, Blake Surina, Fircrest City Councilor, traced the historical connection between University Place and Fircrest. He pointed out that the distinction between the two cities is that they were both planned and platted by the family of George Washington

Frederick Law Olmsted.
Wikimedia Commons.

Thompson. If those are not familiar names, they soon will be, as will the name of Frederick Law Olmsted.

Frederick Law Olmsted was the most brilliant and renowned landscape architect in the country in the second half of the nineteenth century. Per Blake Surina:

> *Among his accomplishments were New York's Central Park, Morningside Park in Manhattan, and Brooklyn Parkway (in fact it was Olmsted who coined the term Parkway). Other accomplishments include the design of the suburban community of Riverside Illinois, which Olmsted himself stated, "has gracefully curved lines, generous spaces and the absence of sharp corners, the idea being to suggest and imply leisure, contemplativeness and happy tranquility."…*
>
> *Thirty years later with the advent of the second transcontinental railroad terminus coming to Tacoma, optimism was revived. One such land speculator was infamous Major Edward J. Bowes and his partner W.A. Irwin of California, who saw tremendous opportunities for growth in Tacoma.*

In the forties and fifties, everyone knew Major Bowes, even though he wasn't rich and he wasn't a major. He'd never even been in the armed forces. In fact, he grew up poor as dirt and even put himself through high school by doing calligraphy. He always knew though that he'd be rich one day.

110

Major Edward Bowes never saw any military service. He created *The Original Amateur Hour* and discovered Frank Sinatra. *Wikimedia Commons.*

Major Bowes wasn't a member of the armed forces. He wasn't rich, but he knew how to put bits of business together successfully and never doubted that he had the fabled Midas touch. All through high school in San Francisco, where he was born, he supported himself doing calligraphy—name tags, invitations. Opportunity finally came from a surprising place. A great earthquake struck in 1906, and Bowes quickly acted upon the opportunity that comes with disaster. He quickly bought up ruined buildings in the quake area that he felt would be rebuilt and come back.

Surina continues,

> *This paid off in such a big way that Bowes began to look around for other pockets of unclaimed wealth. It was no surprise that he turned his eye to Tacoma, Washington. In those days, it was not only one of the fastest-growing cities in the United States but also called the City of Destiny, expected to be the major West Coast port and the terminus of the railroad. Bowes wanted in on the action.*

When Tacoma was awarded the bid in the late 1800s to be the terminus for the railroad line in Washington, there were grand plans for the city. Accompanied by a group of investors, Bowes made the trip up to Tacoma in October 1906 on the streetcar. "The last real big hunk of property left on that line was Fircrest," so Bowes and his investors purchased the land that Fircrest is on today.

Eventually, Edward Bowes's interests changed. In 1910, he sold Fircrest and started buying up theaters around the country, eventually getting involved with the RKO Keith Circuit, the great vaudeville circuit.

Albert Fisher is a longtime television producer who worked on the *The Original Amateur Hour* after it transitioned from radio to television. He recalled, "Every radio in America was tuned to *The Original Amateur Hour* when it came on. Much like today's *American Idol*, the program was devoted to discovering future stars, and indeed, Major Bowes did discover Frank Sinatra. It was the biggest thing in the history of radio up until that time." He also offered a "plate night" at the theater. If you attended a show, you got a free plate, and in those depression days, you could build a whole set of dishes that way. Dishes also came in detergent boxes, but that's another story.

There's still no university in University Place. Kristen Kendle explained its nickname: "Fondly called UP (as in yoo-pee, not "up") by locals as in I am a yoo-pee resident" UP, now home to more than thirty-one thousand people, has with the Chambers Bay Golf Course finally taking the leap forward it tried for more than one hundred years ago. There's a beautiful city hall complex that includes a wonderful public library, and a state-of-the-art shopping center is planned. It has the area's only Whole Foods, and Trader Joe's. And it's possible to say after that all these years, University Place has its institution of higher learning. A person can learn a lot playing golf—or building a golf course.

MILTON: THE MULE THAT RAN FOR OFFICE—AND WON

THE STORY THEY TELL

We weren't actually in Milton when I heard this story. We were in a neighboring town, and workers at city hall dragged out the yellowing newspaper archives. "Be sure you go over to Milton," they chortled. "You know, that's the town that elected a jackass mayor. Right here in the papers," thumping the page for emphasis. You know what? It was true, pretty much.

THE REST OF THE STORY

The legend, perpetrated by city council members of surrounding towns, is that the folks of Milton were so clueless and lacking in civic awareness that they elected a mule to be mayor of that small town. The truth is something quite different.

Milton's founder and mayor, Ken Simmons, became convinced that people did not inform themselves properly about the candidates they were voting for, so he submitted a candidate of his own. The mule, Boston Curtis by name, was put forward for election. In a story that's as relevant today as it was eighty years ago, Boston Curtis was elected and actually served for the better part of a year.

The Town of Milton was incorporated on August 16, 1907, but it was that mule named Boston Curtis who put it on the map, or at least in the papers, in 1938.

According to the record, Boston Curtis ran for Republican committeeman, not mayor, but otherwise, the story is true. Named Curtis for the people who owned him and Boston because it just sounded so proper, the candidate appeared as required in person with all of his paperwork filled out in advance and signed with the print of his hoof—which for some reason didn't seem unusual to anyone.

Since voters often come to the polls knowing nothing about the candidates and simply choose the most appealing name, it's not surprising that the dignified sounding Boston Curtis won. He received only fifty-one votes, but that was enough.

The candidate was sponsored by the mayor of Milton, Kenneth Simmons, a Democrat, who said that he did it to prove a point. He believed people don't bother to find out enough about the candidates they vote for.

Simmons made his point and his mark. The story of the mule hoax was told and retold around the world. More than fifty papers carried the story in that pre-internet era, pointing out that Republicans had voted for this "cousin of the Democrat's donkey symbol." As *Time* magazine put it, "Mayor Kenneth Simmons chortled hugely. He had proved his point that voters 'have no idea whom they support.'" The story was highlighted on the famous *Ripley's Believe It or Not* radio show and book and is featured in the Museum of Hoaxes. All of a sudden, the nation knew where this tiny Washington town was located.

The people who knew Ken Simmons as a boy were certainly not surprised. Ken was a high-spirited kid, an excellent swimmer. His high school chum Leonard Nelson wrote that Ken, called Catsup by his friends, had competed for the Tarzan role that went to Johnny Weissmuller. Nelson also said Ken Simmons was once arrested as a youngster for stealing a life-size mannequin and throwing it off the Narrows Bridge, causing people to think it was a jumper. This nearly landed him in jail, but he was excused because of youth. Ken Simmons also kept a pet bear for a while—not your average guy. Simmons founded the town of Bonney Lake in what many considered a questionable land deal with one thousand acres won on a bet from a rodeo man according to one legend. There's a monument in the Ken Simmons Park in Bonney Lake with an inscription that begins "Whether you consider him a scoundrel or a hero." That's not the usual tribute, either. But I talked with his daughter-in-law, Joan Simmons Branch

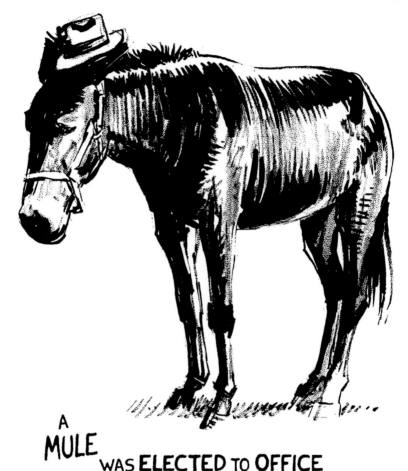

Ripley's——Believe It or Not!

A **MULE** WAS **ELECTED** TO **OFFICE**

A DONKEY'S NAME WAS PUT ON THE BALLOT AS A JEST
AND WAS ACTUALLY NOMINATED REPUBLICAN PRECINCT
COMMITTEEMAN Milton, Washington, 1938

The story of Boston Curtis was featured on Ripley's Believe It or Not ® Show. *©2016 Ripley Entertainment Inc.*

Ken Simmons, who served as mayor of Milton and founded Bonney Lake, sponsored the mule Boston Curtis for Republican committeeman. *State Library Photograph Collection, 1851–1990, Washington State Archives, Digital Archives*

still lives in the area. Ken Simmons has many relatives and extended family members in Milton and Bonney Lake who remember him in a variety of ways, but all agreed that his wife, Bertha, was the heart and soul of the family. "You can't talk about Ken without talking about Bertha," said Joan Branch, who added that she never experienced anything but kindness from the couple.

But the Boston Curtis adventure was in a class by itself. Newspapers across the country had a field day with Boston Curtis's day in the sun.

Time magazine reported,

> *On September 13, 1938, Boston Curtis became the new Republican precinct committeeman for the town of Milton, Washington. Most remarkably, Curtis achieved this despite the fact that he was a brown mule. As it turned out, the whole stunt had been arranged by Democrat Milton Mayor Kenneth Simmons, who wanted to make Republicans look foolish and show that the average voter had no idea who he was supporting.*

The Museum of Hoaxes puts it this way:

> *Boston Curtis's election victory was engineered by Milton's Democratic mayor, Kenneth Simmons. Simmons had taken the mule down to the courthouse and placed its hoof print on all the documents necessary to*

register it to run. The hoof print appeared on the records as a smeared mark. Simmons also signed his own name to the documents as a witness.

In 1938, Simmons entered Curtis into the election for the post of Republican precinct committeeman for Milton. He ran unopposed and was elected on September 13, 1938 by 51 votes, despite having run no election campaign, or offered a platform. Residents were surprised to learn that Curtis was actually a long-eared brown mule.

The mule later crossed the floor, joining the Stevens lobby.

It is somehow comforting to realize that pretty confusing news campaigns were not invented in this century.

Ken Simmons's heart remained with Bonney Lake and with Milton. During the early 1890s, a mill was constructed amid towering evergreens on a hill overlooking the Puyallup Valley. The first settlement, known as "Mill Town," was made up of a handful of homesteaders and the lumber camp workers who furnished timber to feed the mill. The name became Milton only after the postal service rejected the two-word Mill Town moniker. Besides, government officials said, Washington already had one Mill Town. Residents were actually quite pleased with the change, as the town was then named after the renowned poet.

"Milton's a rather prickly little town, but fiercely independent, with their own police department, and even their own power and light. Safety and Security are a priority," explained Mayor Pro Tem Lois Zaroudny, "My parents came here because of the quality of life. People stay here or they come back."

Ken Simmons died on December 27, 1981, at the age of seventy-seven. His obituary listed these accomplishments:

Kenneth H. Simmons, Bonney Lake's mayor from the day it incorporated in 1949 until the late 1960's died Sunday.

A three term state legislator from the 25th district, Mr. Simmons was the driving force in Bonney Lake's incorporation after purchasing a large parcel of property there in 1947. The area however, needed a fresh-water supply system and Mr. Simmons fought for the water system soon after Bonney Lake was incorporated by launching a revenue bond issue. He was active in the Pierce County Democratic Party, was past president of the Puyallup Eagles Lodge and was past master of the Sumner Grange.

He also was a member of First Baptist Church of Tacoma. Mr. Simmons gained national attention in the 1930's when he filed the name

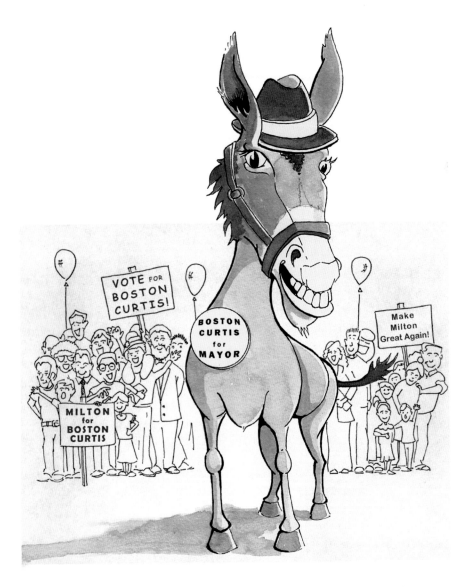

Boston Curtis complied with all regulations to run for office of Republican committeeman. He won! *Original art by Mark Ryan.*

of Boston Curtis as a Republican precinct committeeman for the 25th District. It was discovered after Boston Curtis was elected that the individual was a mule—a humorous stunt which later became known as the "donkey incident."

That old gang of mine, Milton 1930s. *Library of Congress, Prints & Photographs Division.*

Mr. Simmons, a retired real estate broker, continued throughout his lengthy political career to promote the town of Bonney Lake, continually pressing for new developments and improvements.

Born in Tacoma, Mr. Simmons had resided in Milton for 41 years, serving many of those years as that city's Mayor. He had resided in Bonney Lake for 36 years.

And so, that's the story of the mule that ran for office and won. It seems appropriate to close with that inscription from the memorial stone in Ken Simmons Park:

Whether you consider him a rascal or a hero, Ken Simmons was the driving force behind the development of Bonney Lake. After purchasing a large parcel of property about 1946, which encompassed Bonney Lake, he began to clear the Fallen Logs and debris from the lake. He created a recreational destination by building a clubhouse, boardwalk high diving board and swimming area.

Dances at the clubhouse and picnics at the beach promised a great summer attraction, not only a great summer attraction not only for plateau

residents but also enticed resident visitors from the warm valley towns. The resort proved to be a great marketing tool when be began selling lots in the new city of Bonney Lake.

Ken Simmons was not an ordinary guy.

Eatonville: Painting the Town Red

The Story They Tell

The town of Eatonville may be the root of a phrase commonly used in the last century for a festive occasion. "We're going to paint the town red!" was the enthusiastic cry. However, there's no question about the character and temperament of T.C. Van Eaton, the town's founder. He was a man of strong opinions who always left his table with a smile—or at least he left a smile on the table. He often took his teeth out to eat and forgot to replace them.

The Rest of the Story

Painting the town red—who knows where that phrase originated? Eatonville residents told me that it grew out of one of their own natural resources. The Mashel River, which runs through Eatonville, carries a deep and durable strain of copper that made a bright long-lasting shade of red when used in paint. Soon, Mashel Red was popular all across the country, and in Eatonville, almost all of the buildings were that color. T.C. Van Eaton also sold that red paint to the railroads for that distinctive caboose and boxcar color. The red paint was very much in demand from one side of the country to the other. In one location after another, the distinctive Mashel Red shipped from

The original little red cabin base of the T.C. Van Eaton family and the last building in Eatonville painted Mashel Red. *Photo by Pat Van Eaton.*

Eatonville was enthusiastically snapped up to add the unique hue to towns across the United States.

Cyrus Snow became the first mayor of Eatonville and was the man who discovered the paint properties of the Mashel River. Around 1900, Eatonville was painted red—Mashel Red that is.

The Eatonville to Rainier newsletter observes:

> *Mashel Red, also known as paint rock, was an Eatonville industry for a short while. The rock, unique to Eatonville with its red (almost maroon) color, was used as a paint pigment. According to the* History of Tacoma Eastern Area, *"He* [Snow] *came here in 1900 investigating a rumor that there was copper near Eatonville. He became superintendent of the Success Paint Company, which used copper ore as a base for its paint pigments. Cyrus Snow filed mineral rights on a claim on land south of town. The shafts built to sample the rock below could still be seen on the banks of the river. The rock was of such a nature that it could be easily crushed. It was refined and screened and mixed with linseed oil." "The*

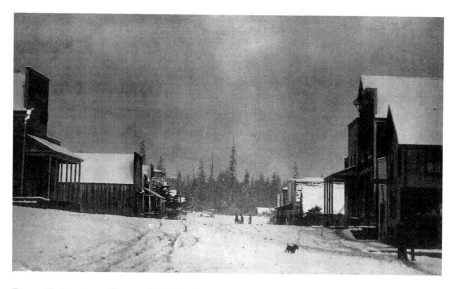

Eatonville in winter. *Courtesy of Pat Van Eaton and Van Eaton family.*

paint was marketed to the railroads for its anti-rust properties because it had small amounts of copper in it," says Pat Van Eaton, T.C.'s grandson, who lives in Eatonville today.

Eatonville is the sort of town that Norman Rockwell would have loved to get his brushes on—the American Legion hangs American flags on all the streets. The chamber of commerce puts up elaborate hanging flower baskets, and Kirk's Pharmacy dispenses hugs along with prescriptions.

T.C. Van Eaton was born on June 26, 1862, the first Caucasian child born in Pope County, Minnesota, and the youngest of five born to a Methodist preacher who rode circuit to churches in the area. But it was a long, perilous journey from Minnesota to Washington Territory, and T.C. was not prepared for the difficulty of making his way through the rugged mountains. There aren't many mountains in Minnesota.

Everyone who knew him agreed that all his life, Thomas Cobb Van Eaton dreamed of building a town that would be named for him. Being the sort of man he was, he didn't leave it for someone else to confer this honor. When it didn't happen right away, he did it himself.

In 1887, T.C. and his brothers set out for the West. They were all skilled builders and found plenty of work along the way to finance their venture. T.C., who was a skilled carpenter, did roofing for the army posts along the way to make money, as did his brother-in-law, who was traveling with him.

T.C. Van Eaton and bride. *Courtesy of Pat Van Eaton and Van Eaton family.*

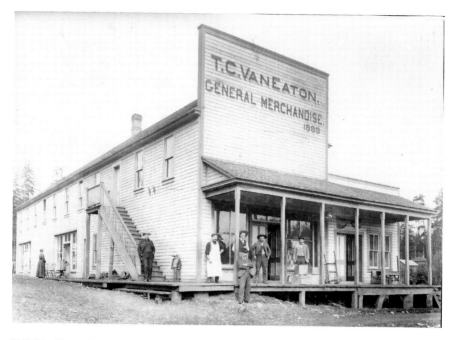

T.C. Van Eaton Store. *Courtesy of Pat Van Eaton and Van Eaton family.*

T.C. Van Eaton and company headed westward with a party of eight wagons. Midway across the country, when his wife, Lenore, became too ill for the jolting wagon, he sold his wagon and equipment to put the family on the train. It was a long, rugged journey. The railroad labored over one switchback after another over the summit of the pass. Passengers jolting along could look down and see that they'd switched across the roadbed three and even four times below. Robert Van Eaton shared family stories of that train ride over the mountains. Mr. Robert (as we called him) was Van Eaton's youngest son, born of T.C.'s third marriage, to Nellie Appleby. (Lenore Van Eaton died in 1891.) T.C. married a second time to Mary Jane Osborne, who died in 1906, and then to Nellie Appleby who, had come to work for T.C. and care for his four children. She was, by all accounts, a great match for T.C.

Mr. Robert told the stories of the perilous crossing as if he'd been there and also remembered that after they'd crossed the mountains again, and again, they crossed the mountains coming to Tacoma, looked ahead and saw even more craggy peaks ahead. "That's enough," T.C. said. "We stop here." In Tacoma, T.C. Van Eaton jumped right in the day after arriving and built a cabin across from Union Station. After six weeks, he sold it and

purchased a lot at Seventeenth and Kay Streets and constructed his own home. Van Eaton worked several jobs in Tacoma. After two months, T.C. decided he could do better doing his own contracting. With only $42, he took a contract to build six homes. He was accustomed to working with pine, oak and elm, but quickly caught on to using the magnificent fir, cedar and hemlock lumber that grew in profusion just for the taking. His work and his reputation grew—so much so, that a man who watched him loaned him $100 to continue. Van Eaton had a gift for management and handed the keys to the owner of the first house within nine days. By the time the second house was done, Van Eaton was able to pay back the $100 loan. All the houses were completed at the rate of one house a week. He had all six done in six weeks. From the never-ending flow of people to Tacoma, T.C. was busy from that time on, but he knew that this was not the spot where he wanted to make his permanent home.

A guide called Indian Henry, so the story goes, showed T.C. to a pristine spot that had everything: mountains, trees, a beautiful fast-running river and endless possibilities. This would be the place where the Van Eatons would make their home and build their town. When T.C. arrived in the new city of Eatonville, he built a log cabin, and it remains today. People wanted

Mr. Robert Van Eaton's early home. *Courtesy of Pat Van Eaton and Van Eaton family.*

to call the new town Van Eatonville, but T.C. said that was too long and complicated. "He said just call it Eatonville. That was fine with him," Robert Van Eaton remembered.

T.C. Van Eaton moved on to the business of choosing the spot that would house both his business and family. He searched the area and found that someone else had already chosen it. He came upon "Hank the Squatter" camped in this location and paid him fifty dollars to move on. Next, he built a seventeen-by-twenty-seven-foot cabin of split boards planed by hand with split shakes for a roof. This would serve as home in the back with the trading post in the front. This post became a main source of provisions for many in the area. Soon, Van Eaton established pack trains and stage lines, bringing more necessities and people to and through his little settlement.

T.C.'s Trading Post was started in 1889. With one new project after another, it seemed he couldn't do anything wrong. There was Clay City, the wonderful clay that could be made into world-class brick. T.C. was a man of strong ideas. Grandson Pat Van Eaton remembered, "He had a lot of strong opinions, most of which he never changed. He never used barbed wire for fencing He claimed livestock couldn't see it and would hurt themselves. Instead he used one-by-six fir boards to fence his 160-acre homestead."

Pat Van Eaton was very helpful in putting his grandfather's story together. Pat gathered his grandson and granddaughter one day and talked to them about T.C. for our cameras:

> *My grandfather was a big man....He was six-foot-two and weighed 190 pounds. I used to eat at the same table, but I was very little. The food came to him first. He was a big person and a very stern person, but he did a funny thing. His false teeth hurt him, so he took them out and put them on the table and they grinned at us while he cut his corn off the cob so he could eat it.*

T.C. was a gifted speaker and gave many speeches. He was head of the Pioneer Association of Pierce County as long as the association and the members lasted. Requirements for membership were stringent. Pat Van Eaton speculated that the organization died because no new pioneers of sufficient credentials presented themselves. After all, the pioneer era was passing.

T.C. miscalculated the direction of government in 1895. He had a large orchard on the Mashel River and used it to irrigate the orchard. Someone suggested that it might be wise to obtain water rights.

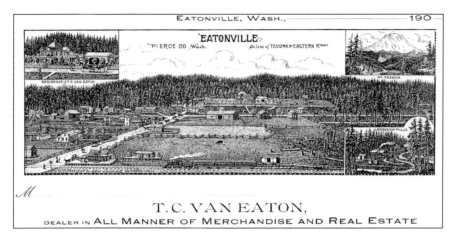

T.C. Van Eaton Store advertisement. *Courtesy of Pat Van Eaton and Van Eaton family.*

T.C. scoffed and said, "There will always be more water in the Mashel River than anyone can use." And that was true, but the plentiful water is no good if there's no right to use it. As time went by, restrictions became more and more complex. Licenses and water rights were difficult to get. Eventually, T.C. couldn't bring water to the orchard at all, and it failed. Only an occasional tree remains as a reminder now. The river is still there. T.C. made and lost many fortunes. He was a shrewd businessman, but his personal life was filled with sorrow. He lost his first two wives and three children to the diseases prevalent in those days. These losses certainly encouraged his interest in bringing modern medicine to Eatonville.

Pat Van Eaton reminisced about the many businesses that T.C. created, which brought much industry to Eatonville and enabled it to survive when surrounding towns withered and disappeared from the map. T.C. added growth to the town by selecting the businesses that would be important and giving the owners the land to build their business. In this way, Eatonville acquired two blacksmiths, a hotel, churches (Catholic and Methodist), a bank and a school. Then the railway came, as did a sawmill operation, which alone employed 250 men. And then Electron Hydroelectric arrived and provided employment for 2,000 men. Eatonville prospered. In 1893, T.C. gave land for the *Eatonville Dispatch* newspaper office, and it is still published today.

T.C. believed in education, though he himself had only completed grade school studies. By 1916, Eatonville was the proud possessor of the best education district in western Washington. Eatonville still boasts an excellent

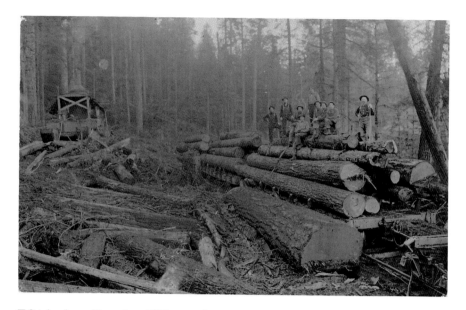

T.C.'s lumber mill employed 250 men. *Courtesy of Pat Van Eaton and Van Eaton family.*

independent school district built on that original 160 acres. Finally, a doctor came to town. He became an Eatonville booster and built a hospital above the drugstore. Eventually, Dr. Albert Bridge founded the highly esteemed and much loved Mary Bridge Pediatric Hospital in Tacoma, named for his mother. These forward-looking men are credited with creating one of the first successful medical insurance plans. For only one dollar per person, all medical expenses were covered.

The Van Eatons' first home in town, that small log cabin, still stands right there at the corner of Mashel Avenue South and Alder Street. It was the first building in town painted Mashel Red and is still painted red, although the authentic Mashel Red is long gone.

Pat Van Eaton recalled that T.C. Van Eaton ran for and was elected to the Washington State legislature from 1893 to 1895. His involvement in social issues continued, as he served on the Eatonville School Board for many years.

As T.C. grew older, he still loved getting involved around the community. He enjoyed baseball and sponsored many teams. All the young men around were welcome to join. The Native American players from the Mashel Prairie were said to be the best in the area. They joined up with some talented Ohop and Eatonville players going up against other local teams. Some places did not want to play with teams that had Indians on them.

A game in Kapowsin was almost called off because Eatonville had Native Americans on the team. So, T.C. got them to agree to play by placing a wager on the game. Pat recalled that T.C. waited until the Kapowsin team was so far ahead that they became overconfident. Louie Jack pitched that day, and Eatonville was behind 2–1. Van Eaton stepped over and told the fellows he would give them $10 a homerun and $5 for a strike. Then, he bet them double the wager originally offered if they'd let the Native Americans play. That was too good to pass up, and they figured that they couldn't lose. The Kapowsin team took the bet, and with those new members on the team, Eatonville won. With that, the team got fired up, and Eatonville won with a whopping score of 10–2. T.C. left with $2,000 in extra cash that day.

If money was lost, his wife, Nellie Van Eaton, knew how to make more. She ran a restaurant and the family farm and sold insurance. Never idle, Nellie was constantly making and growing things. She not only grew gorgeous flowers but also was skilled in preserving them. There were so many flowers that she made bouquets and enlisted her grandchildren to sell them around town. Her grandchildren remember her as industrious. "She toiled planting vegetable gardens and fruit trees. Her little orchard was full of fruit. Even while sitting, Nellie kept busy tatting and crocheting intricate designs," Pat Van Eaton recalled.

T.C. traveled the country in a covered wagon, but he never learned to drive a car.

"My grandmother drove him in her car that she purchased on her own," Pat Van Eaton told us. "He never owned a farm tractor and farmed with horses until the day he died, and then my grandma bought herself a Case tractor."

They were stuck in a time warp, recalled Pat Van Eaton. While neighbors embraced new appliances, T.C. and Nellie continued to churn their own butter and make their own "critter food."

Nellie proved to be more than a companion to T.C. She was indeed his partner. She relished the outdoor life, loving all the children and grandchildren as her very own, and her generous spirit was an example to all. Nellie Appleby Van Eaton died on March 6, 1973. She is buried next to her husband in Eatonville Cemetery.

"One thing more that I remember," Pat Van Eaton said, "the town has a breathtaking view of Mount Rainier, but my grandfather would never call the mountain 'Mount Rainier.'" (The current name was given by George Vancouver, who named it in honor of his friend, Rear Admiral Peter Rainier.)

T. C. Van Eaton
Republican Candidate for Representative in Congress, 2nd District, and Wife.

Above: T.C. ran for Congress and put out this poster; Nellie is listed as "and wife." *Courtesy of Pat Van Eaton and Van Eaton family.*

Left: Nellie Van Eaton, T.C.'s third wife and true partner. She could drive a car and a tractor. *Courtesy of Pat Van Eaton and Van Eaton family.*

"He called it Mount Tacoma, and it was even listed that way on his stationery." In fact, one historian even used the letterhead as proof that the name of the mountain wasn't changed until the twentieth century.

Why? "Well," explained Pat Van Eaton, "Rainier was British, and my grandfather wasn't one to forget a slight. He said 'That SOB fought against us in the Revolutionary War.'" That settled that.

Buckley: The Great Wine and Swine Wreck

The Story They Tell

The story ran like wildfire around the Puget Sound on the morning of May 23, 1891. There had been a huge wreck; a train carrying alcoholic beverages collided with another train. The newspapers of the day say that the other train involved in the wreck was carrying pigs. So it became *The Great Wine and Swine Train Wreck*.

The Rest of the Story

The Town of Buckley was incorporated on May 22, 1890, and named after J.M. Buckley, a railroad division superintendent. Under its earlier names of Perkins Prairie and White River Siding, it was one of the first settlements in Washington.

Today, Buckley is a town of about five thousand and as typical as a small American town gets. Look at the statistics: 51 percent married, 99 percent speak English as their first language and 72 percent were born in Buckley. It looks as if it would be possible to present a production of Thornton Wilder's classic *Our Town* on Main Street with no changes necessary in cast or set. Driving into town, strangers are greeted by the proud slogan "Below the Snow—Above the Fog."

Tourist attractions include the lookout station that once stood at Salmon Ridge, intended for volunteer firefighters and forest rangers to sweep the area and spread the warning at the first sight of fires. With the advent of electronic fire-spotting aids, these stations have pretty well gone by the boards. The lookout station is a favorite spot for tourists and class pictures. If you're lucky enough to arrive during the last full week in June, you can take part in the log show where chainsaws are thrown about with alarming alacrity and there's an elaborate obstacle course made up of all sorts of unlikely logging feats that must be undertaken and accomplished. Every year, the annual Log Show and Parade honors the community spirit of Buckley as it "preserves the past, celebrates the present, and embraces the future." In June 2018, Buckley celebrated the forty-fifth annual Log Show.

Buckley depended on the railroad for its beginning and continued survival. Once the Northern Pacific Railroad added tracks between Cascade Junction and Buckley in 1884, the railroad renamed the town White River Siding for the nearby White River. Finally, in 1888, the railroad continued its tracks to Stampede Pass. The town was again renamed. This time it was Buckley, and that stuck.

Of course, the spirit of community comes from the people who live there. Mayor John Blanusa, credited with being one of the originators of the Log Show, held the office of mayor from January 1, 1994, to December 31, 2005. He was a genial man who was fond of saying, "Age is just a number—and mine is unlisted."

On a shelf near his desk, where it was bound to catch the eye, was a framed picture of a train roaring across a trestle. John Blanusa died in 2017, but his stories, commitment and love for his community are still remembered in Buckley. As he often said, "We're all one family."

The Wine and Swine Train Wreck was the train wreck to surpass all train wrecks—and it happened like this. The May 23, 1891 issue of the *Buckley Banner* carried this story about the morning the wine flowed like, well, wine. Here are the article and headlines as they appeared:

COLLISION OF FREIGHT TRAINS

Iron Horses Bump Together at White River Bridge.
A Gala Day for Buckley.
Free Wine and a Free Fight.
Fourth of July Nowhere in Comparison.

Early Thursday morning as freight train No. 56 pulled out of town and swung round the curve in the cut this side of White River bridge her engineer caught sight of another freight train clattering across the bridge.

The air brakes were quickly turned on and the fireman and engineer jumped for their lives, the men on the other engine doing likewise, and the two engines slammed together and locked horns, as it were, about a hundred feet from the end of the trestle. Had the east bound train been a few seconds ahead the collision would have occurred on the bridge or trestle, which are nearly half a mile long and nearly a hundred feet high at most points, and the train men would have gone to sure destruction. As it was no one was hurt, and as both engines and most of the cars remained on the track, the wrecking train which arrived on the scene shortly before noon made quick work of clearing up the debris, and the passenger trains got through at about 2 o'clock.

A car-load of ice and one of grain were thrown clear off the track, and another car containing a lot of hogs was pitched to one side and badly smashed.

A car containing forty-five barrels of wine of different kinds was almost completely telescoped by the tender of the east bound train, and the wine

Trains brought the West together, too fast sometimes. *State Library Photograph Collection, 1851–1990, Washington State Archives, Digital Archives.*

135

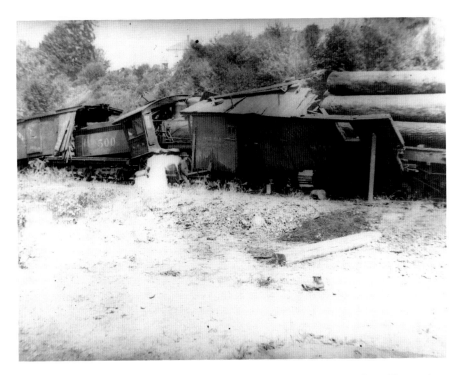

Wine and Swine Wreck, Northern Pacific train wreck, 1880–1940. *State Library Photograph Collection, 1851–1990, Washington State Archives, Digital Archives.*

flowed in streams in every direction. A few barrels were thrown out of the car by the concussion and saved intact.

The news of the occurrence reached Buckley at an early hour, and before 7 o'clock many had started to view the wreck, and number increased till the railroad track was lined with men, women and children hastening eagerly forward to the scene of the catastrophe. Children forgot to go to school, women deserted their breakfast dishes and men abandoned their positions in the mills which whistled repeatedly to recall them but in vain. Ye Banner man gulped down a hasty breakfast and joined the throng. Once on the track the peculiar aroma of good California wine became noticeable, and ye reporter needed not the frequent admonition of parties returning to make haste to the front. An immense crowd had gathered about the wreck. Many of the ladies and men took positions on the bluff overlooking the scene, but the debris was surrounded by a vast army of men and boys, most of whom were bunched immediately in front of the car which contained the liquor. A continual stream of mixed

drinks trickled down along the whole length of the side of the car, and tin pans, old cans and every kind of vessel that could be brought into requisition were rapidly filled and drained off, while many began to arrive with buckets and milk pans to obtain a supply to take to their homes. The scene was amusing and yet in many respects extremely disgusting. Boys and men, unable to obtain a dirty old tin can, would occasionally hold their mouths under the drip and guzzle like hogs catching drips under a watering trough. People continued to arrive from both sides of the river and buckets continued to increase. Section men and members of the steel gang instead of protecting the company's property joined the hobos and made the most of their opportunity to get full. A number of church members, noted for their piety took an active part in the exercises, and an effort was made by a photographer present to include them in a photograph of the scene but not with much success, as they retreated until he changed his position.

They still talk about the collision in Buckley. Sometimes, little boys try to put objects on the tracks to replicate that wreck, but thankfully, they haven't been successful.

Heart and Soul

STEILACOOM: THE GHOST IN THE MANSION

THE STORY THEY TELL

A beautiful, picturesque and historic village is bound to have its share of ghosts and unexplainable happenings. There's probably some sort of rule about it. Any visitor to the small but lovely city of Steilacoom is bound to hear two things right away. Thing one: Steilacoom was the first incorporated city in Washington. Thing two: The second factoid is pretty likely to concern the ghost at the E.R. Rogers mansion. The fact is that this whole historic area is reported to be replete with ghosts and hauntings. I did meet the ghost at E.R. Rogers's home in person—and he didn't like me at all.

THE REST OF THE STORY

It stands to reason that this historic town would have a ghost—in fact, several have been reported—but this chapter deals with close encounters with the ghost in the E.R. Rogers mansion. Rogers, a seaman and merchant, found himself newly rich and built a grand home in 1891. Within two years, he experienced financial ruin and the mansion went to his archenemy, Godfrey LeFevre (Cub) Bair. Since E.R. had only two

years to enjoy his wealth, perhaps he couldn't have been expected to give up this life gracefully, but there are many stories of his appearances after he had gone on to his reward. More of that in a moment, but first let's set the scene.

Steilacoom is rightly proud of its status as Washington's first incorporated town. In fact, this small feisty city claims many historic firsts for the territory and then the state of Washington:

- First territorial court, held at Fort Steilacoom in 1849
- First port, 1851
- First post office, 1852
- First Pierce County seat, 1853
- First public library, 1858
- First school, 1854—The first public school in the county started in summer of 1854 when twenty-seven children met in an improvised classroom in the living room of teacher Lydia Bonney (wife of Sherwood Bonney). The Methodist Episcopal Church was organized and held services on August 28, 1853. The building was constructed in March 1854. The upper story was used for church purposes, and the lower floor was used for a school and gathering place for social and political activities in 1887.
- First courthouse, 1858—John Chapman, an Indiana lawyer and fiery orator, donated the land for the courthouse. The county offices were downstairs in one large room. Court was held upstairs, allowing litigants to take their case to a higher court.
- First jail, 1858—The Territorial Jail was built in 1858 on land donated by Lafayette Balch. The jail housed local, territorial and federal prisoners until the McNeil Penitentiary was opened in 1875.
- First Brewery, 1858–1858 was a big year.
- The first Catholic church in Washington State, moved from Fort Steilacoom, was consecrated in Steilacoom, 1864.

The Steilacoom Library Association was incorporated by a special act of the territorial legislature in February 1858. It was the first civic organization in the county. Funds were collected locally, and Philip Keach sailed to San Francisco to buy books for the new institution. The historic Steilacoom library books are now housed in the Steilacoom Historical Museum.

First grade class at Steilacoom Elementary School, 1948. *Courtesy of Lenore Rogers.*

Steilacoom is just as proud today of these accomplishments as it was the first day it became a city. Everybody turns out for the Fourth of July parade, but the people of Steilacoom are proud every day of the week. One resident even created life-sized caricatures of early Steilacoom residents that come out on the porch to enjoy the Fourth and other special days.

Lifetime resident, historian and community activist Lenore Rogers supplied the earlier list of historic firsts and added the best things about living in Steilacoom:

No stoplights
Easy to walk to work/school
Kid friendly
Two public beaches—one sandy, one rocky
Spectacular water and mountain views
Concerts in the park
History is preserved without being cutesy
Excellent medical response
You don't have to leave town to get a latte

POST OFFICE DEPARTMENT

In 1853, Steilacoom was awarded a contract to be the first post office in the area. This is the notice received by the postmaster:

> *Contract Office 18 Jan'y, 1853*
> *Sir:*
> *Your office is to be supplied with the mail once a week from Olympia, distant 28 miles.*
>
> *The expense of so supplying it is to be defrayed wholly out of the net proceeds of postage collected at your office, including postage on letters and papers sent prepaid by stamps, and is not to exceed the sum of 140 dollars a year or $35 a quarter, the surplus, if any, to be retained, subject to the order of the Postmaster General. J.B. Chapman is accepted as Contractor, to perform this service, which is to commence on the earliest date practicable.*
>
> *If he has failed to commence, engage some one else at the lowest limit practicable, (limited, however, to your net yield).*
>
> *You will report the date of actual commencement of service, and by whom; also the days and hours at which you have arranged the departures and arrivals of the mails in each direction, at each office.*

On November 12, 1853, a similar notice was received by the postmaster at Steilacoom, except that the name of W.M. Smith appeared as the carrier. This second appointment is also contained among the files of the late Judge Chambers. The first mail to Steilacoom was carried by canoe from Olympia.

So that should be enough to establish Steilacoom as a dignified, historic place, a city to be taken seriously. Now, let's take another look at the stately building at 1702 Commercial Street, the E.R. Rogers mansion. If ever a building deserved to house a ghost or two, it's this one. The house had a beginning that was typical for the times. It was built by a successful seaman and merchant, impressive and beautiful even by the opulent standards of the day (the mansion, not E.R.) With his wife, Catherine, and stepdaughter Kate, he settled in to live happily ever after.

Unfortunately, ever after was only two years away, because in 1893, they lost everything in a financial disaster. After the Rogers family lost the house, they moved back to their old home next door and had to watch as local businessman Charles Herman bought the mansion from Cub Bair and turned it into a guesthouse. It must have been difficult living right next door to the beautiful house he could no longer have. And it's possible to imagine

E.R. Rogers Mansion. *Courtesy of Joe Mabel.*

that E.R. was determined to get his house back, even if he could only do it in ghostly form.

The mansion is apparently home to a variety of ghosts, and portions of ghosts. In fact, one ghost is described simply as a woman's stockinged foot on the stair, but as Kathleen Merryman wrote in the *Tacoma News Tribune* in 1991, "there is no floor beneath the woman's foot." The foot and fragment of lower leg come into view, appear to be climbing a stair and then disappear. The reporter went on to note that the stair on which the figure steps is no longer there, torn out decades ago when the house was remodeled to become a restaurant, first called the Waverly Inn. E.R. Rogers gained recognition when new owners gave the restaurant E.R.'s name. Merryman continued, "If she is there [the foot fragment ghost], then the building that houses E.R. Rogers' Restaurant is haunted."

Owners and staff and occasional visitors to the E.R. Rogers mansion have all reported that the spirits are there. Observers state that the spirits seem more interested in revealing themselves to the staff or the workers than to the patrons—or maybe it's just that they spend more time together. Over the years, the spirits have been pretty consistent. Doors open, lights flash, a fire burns in a fireplace or there is a sudden overpowering smell of cheap perfume.

Many visitors come away with a story or two, and they're most striking because they're all pretty much the same—appliances turning on, doors swinging open and that step on stairs that are no longer there.

There's one other story all occupants seem to agree on. It seems that E.R. Rogers wants his rocking chair in front of the window looking out on the incomparable broad vista of Puget Sound. He was a sailor, after all. No matter where the chair is moved, even if it's put in a dark closet and the person who puts it away closes the door, maybe locks it even and thinks, there! That's done it. The next morning, or in a day or two, it will be back in front of the window again. That's what they say.

In Steilacoom, even the ghosts have neighbors. There are said to be ghosts around the corner and up the block at the old Bair Store. Cub Bair, of course, is the man who forced E.R. Rogers to sell the mansion. The Cub Bair store is commonly thought to be haunted by the ghost of Cub himself as well as a lady who might or might not be Mrs. Bair.

This 1908 historic pharmacy and general store is now a museum and bistro and is rumored to be haunted. Staff and diners complain of a taciturn spirit that shatters glasses and rearranges cutlery in addition to playing with electrical appliances.

By the 1970s, the Bair Store was in a dreadful state of disrepair. It showed every one of its years and was so swaybacked as the roof caved in that it looked as if it would have to be pulled down if an unexpected gust of wind didn't catch it first. But on April 25, 1975, a work party of volunteers from nearby McChord Air Force Base descended upon the store and, in just a few weekends, had it back together again, with the help of other community volunteers. Today, with many artifacts from Steilacoom's beginnings, it's a very popular lunch place. We don't know how the ghosts felt about this, but I think they had to be glad.

Jeff Dwyer, in *Ghost Hunter's Guide to Seattle and Puget Sound*, observed: "When Cub died, he didn't let death get in the way of his doing a full day's work." The belief is that he's still working; the staff says appliances come on suddenly and wear out from the inside out. Cub's daughter Jane Light, delightful and close to ninety, still lives in Steilacoom, illustrating another truism about this town. The children may go away, but they always come back to live.

When the day came that we were to tape our show at the E. R. Rogers mansion, we gave no credence at all to the idea that the ghost might not like us to be there. We were to meet Jack Sage, a man in love with the stories and spirit of Steilacoom, and the mansion was to serve as a backdrop for a

re-creation of the tour of haunted buildings and scary places in Steilacoom. Sage would surely have been a contender for the title of Mr. Steilacoom.

Jack and I sat and chatted while the crew set up for the shoot. There were three cameras and cameramen. "E.R. won't like this," Jack fretted. "He doesn't like strangers, and he doesn't like cameras in the house." I wasn't too worried. The house was full of pictures, and it had been a private residence, a guesthouse, a restaurant—all bringing strangers and cameras in. I pointed this out to Jack, and he persisted. "Well, he won't like it," he insisted.

The interview started easily as Jack outlined the haunted places in Steilacoom. Finally, we turned our attention to E.R. Rogers. Jack talked about the various sightings, about the footstep on the stair with the portions of anatomy that appear and disappear. He was pointing out to me the portion of floor that had been torn out and rebuilt when he reiterated that E.R. didn't like cameras or anything that came with them. Suddenly, there was a sound from upstairs like something very heavy falling and bouncing. Immediately, the lights and the cameras went out. We sat for a moment in the afternoon gloom of an old building with heavy curtains on the windows. I expected that the crew would have the cameras going again in no time, as they always did when the unexpected happened. This time, nothing the crew could do could get them going again. Changing fuses didn't help, and the camera wouldn't work on batteries. None of the neighbors seemed to be suffering a lapse in service, and Jack didn't seem at all surprised.

Finally, the crew carried the cameras out onto the lawn, where they worked perfectly, and we completed the interview outside without any more problem. It was better anyway, looking out over the water, with the bandstand to one side, the Olympics across and the ferry coming in. I won't say that the E.R. Rogers mansion is haunted. But I will say that something there doesn't like cameras or TV crews.

Now though, things have changed. Attorney Peggy Fraychineaud Gross purchased the mansion, and she now has her law offices there. Peggy and Jeff Gross bought the house in 2006 and, over several years, restored the landmark structure from basement to attic. The new mansion is perfect in every regard, and in a brief interview with Peggy Gross, she told me of the lengths she's gone to make each detail perfect. And perfect it is—even the office reception area is beautiful enough to make a person try to think of a reason to engage legal services. And it seems to satisfy E.R. Rogers, if he's really there.

I asked Peggy Gross if she's experienced any supernatural visitation, and she said no—and then paused and reflected that occasionally the staff

finds lights or fireplace on that they're sure they turned off, but that's easily explained. The E.R. Rogers mansion, restored and beautiful, is a jewel in the historic town of Steilacoom.

Kathleen Merryman revisited the subject of the spirited Rogers at Halloween a year after her first column for *The News Tribune*. She has the final word:

> *People who have tried to live in the house he built—and then lost along with his fortune—say it is Rogers who keeps the chair by the window. They say he doesn't want them there and that, frankly, he's lousy company.*

TACOMA: ARM IN ARM IN ARM— OCTOPUS WRESTLING UNDER THE BRIDGE

THE STORY THEY TELL

It was the middle of the twentieth century, in the fifties and sixties, when TV screens darkened by midnight with the playing of "The Star-Spangled Banner" and program choices were limited. In those years, octopus wrestling wasn't just big, it was huge. This was the time when professional human wrestlers were really hitting the top of the charts on TV, and at the movies, Kirk Douglas was battling a monster squid in *20,000 Leagues Under the Sea*. It seemed perfectly reasonable that the tabloids were filled with stories of the vicious, terrible, awful, really mean octopuses who sat around beneath the waves of the Tacoma Narrows growing as big as boxcars. Some even darkly suggested that they caused the bridge to collapse and then emerged from the water on Ruston Way, just waiting to use buildings for toothpicks, if they had teeth. Nobody questioned the stories. America was coming out of two wars and needed distraction. The octopuses in the currents under the Narrows Bridge were the biggest and the meanest in the world. There was one that tipped the scales at six hundred pounds. That's what they said.

THE REST OF THE STORY

It's absolutely true that octopus wrestling in Seattle and Tacoma reached a peak in the 1950s and the '60s. The "wrestlers" were armed only with knives—and those were only for cutting fishing lines and entanglements, not to be used as weapons. Crowds came down to the docks to watch. It turned out that the cephalopods are really very gentle creatures that just wanted to get away from everybody.

The true story comes from Gary Keffler, who, at eighty-four, still lives near the Underwater Sports Seattle store that he created in 1956, which became the largest scuba diving chain in the Pacific Northwest. He is the former diver who is credited with creating the Giant Pacific World Octopus Wrestling League and is three-time Giant Pacific World Octopus Wrestling Champion. Where did he get the idea to "rassle" octopuses? In those days, before the development of modern diving equipment, the wrestlers went into the water free diving. That is, no equipment was used. This meant two things: the dive couldn't last as long, but the undersea life would allow the divers to come much closer and see the octopus in ways no one ever had before or since. These animals are called giant Pacific octopus or GPOs. Gary recalled, "They were just so beautiful. Sometimes it's as if they're flying through the water as they change colors. Every color you can imagine." If the octopus is not as dangerous as portrayed, the experience was still a very hazardous one. It was easy to imagine that the octopus fighters wore that big old deep-sea protective gear with the bolts on the helmet, and maybe there were glass walls for spectators to watch the mayhem without getting blood spatters on their fish and chips. According to comic books, a very credible news source, octopuses were much meaner then than they are now. This new sport was a nationwide hit, and it happened right down off Ruston Way in Tacoma. On television, wrestling was becoming popular, although it was only available one night a week. Coupled with the very vicious octopuses shown in the movies, to the twenty-four-year-old Keffler and his fellow divers, it seemed like a natural success. They were right. Crowds turned out to cheer the matches, and there was actually a World Octopus Wrestling League.

"It was something to do I guess, go out and rassle an octopus," said Gary Keffler. He says the idea came from members of a local diving club called the Puget Sound Mud Sharks. They organized local events and competitions for spearfishing. Gary won a second and a silver medal at the World Spearfishing Championship in 1963.

Octopus wrestler at work. The new sport was a nationwide hit. *Original art by Mark Ryan.*

"Since we had the largest octopus in the world in shallow water, we decided it might be a nice event to try and run and do—and we did. Turned out pretty good," Keffler said. "It's a challenge. So from that challenge we turned it into a contest." Although it is an established fact that Puget Sound has record-setting octopuses in shallow water, they could be even larger in the deep.

Our attitude toward interaction with animals and sea creatures has changed so much that we won't be seeing octopus wrestling again. But back then, an atmosphere grew that welcomed new, thrilling adventures in all fields, and the world was certainly ready to believe the worst about octopuses.

When hunters looked for adventure, Puget Sound octopuses were the ones they thought of. Take this headline from the *Camas Post*, August 15, 1913:

FIGHTS DEVIL FISH
Diver is Seized by Octopus in 85 Feet of Water.
Only after Desperate Struggle of 45 Minutes Is Marine Monster Conquered.

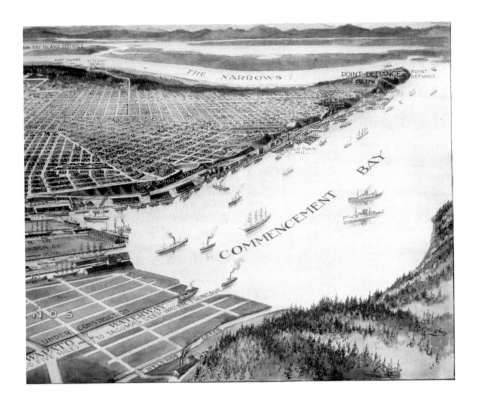

Note that the term "devil fish" was once used to describe the octopus.

How surprising can it be that the same audience got excited about the idea of vicious octopuses in *20,000 Leagues Under the Sea?* That movie was released in December 1954, and it is full of undersea creatures that behave badly. That was followed by *Bride of the Monster,* with Bela Lugosi. Now, you'd think Bela Lugosi would be enough of a distraction for eager audiences, but no, there is a giant killer octopus kept in a tank belonging to a mad scientist (Lugosi). At one point, the mad scientist feeds his adversary to the giant creature. This was followed in 1956 by *It Came from Beneath the Sea,* in which a giant octopus pulls ships and swimmers indiscriminately beneath the ocean. It's easy to see then that this was a time when the world was in the mood for octopus battling. However, even the most casual knowledge about octopuses should have told us that they really don't want to battle at all. So, what happened that made us want to see grown men with big knives battle unsuspecting octopuses who were mostly just going about their business with tranquility in all three of their hearts? The press brought out the story with enthusiasm.

Let's start with *Popular Mechanics* magazine. It was November 1926, way before octopus wrestling reached its peak, when this sedate article appeared:

> *When James Madden caught an octopus in the ocean near Venice, Cal, he decided to test the strength and fighting ability of the creature. He obtained a diving suit and engaged in a wrestling match with his prize long enough to convince him that he was glad he had worn protecting armor for the octopus displayed considerable power in its eight tentacles. Specimens with arms several feet long have been captured.*

At that time, octopus interest was tepid. (This refers to fans' interest, but the octopuses weren't too excited either.) According to this article, octopuses seemed to have itty bitty arms not more than two or three feet long, but only a year later, in the same magazine, things seemed to be getting a lot more dangerous for the diver and definitely the octopus.

Gary Keffler is adamant that people know that no real octopus hunter ever used knives in the way they're described in these stories, but the stories certainly did appear and did help to raise interest in the sport.

Hood Canal, popular for octopus hunting. *Subjects of Environmental Concern; National Archives at College Park, Maryland.*

This article is from *Popular Mechanics*, November 1927:

CAPT. OLE ELIASEN OF NEWPORT BEACH, Calif., killed a large octopus he encountered while at work in the submerged hulk of an old vessel. He was armed only with a knife, but managed to slash the tentacles that encircled him and behead the octopus. He escaped from a larger one and five small ones.

The article does not say where the five small ones came from—although chefs who deal in seafood tell us that large octopuses are rubbery and unpalatable, so if you have a choice, eat the small ones or none at all, which is definitely the octopuses' choice. We have no reason to think the good captain planned to eat any of the octopuses, but the interest was definitely rising.

A decade later, the press began running adventure stories in this magazine and others with such titles as: "Octopus! Terror of the Deep" (*Modern Mechanix*, February 1939) and "I Battled an Octopus for Treasure" (*Modern Mechanix*, November 1939), both by Lieutenant Harry E. Rieseberg, who seemed to fancy finding sunken treasure. This would have been workable, except that the treasure always seemed to have a very large octopus sitting on it. It's immediately evident to the reader that they're not going to get along, because the author describes the octopus as a sea dragon or "monster from the deep" and goes on "hacking the tentacles from its body" before finally observing, "When you wrestle and kill an octopus, you're ridding the marine world of a treacherous enemy."

So the world was in the mood to look at octopuses and wrestling as the next big thing on TV. There was certain to be a perfect storm where it rains cephalopods instead of cats and dogs. So how come this all happened in the Puget Sound and not, say, in the waters around Los Angeles, where people are reputed to do nutty things? It's because the waters of the Sound conspire to create an octopus-friendly climate like none other in the world. In the Sound, especially in the shallow waters around the San Juan Islands, octopuses are the largest in the world. Your average run-of-the-mill Puget Sound octopus weighs around 150 pounds went the stories (a ten-fold exaggeration). Their arms reach from fifteen to twenty feet—you wouldn't want to turn your back on one, so you'd just as well wrestle. That's just the average ones. There were those stories that the big ones weigh as much as 600 pounds.

Gary Keffler scoffs at the idea of the giant octopuses. "I don't know where you are getting that 600-pound one from....I never saw one," he said. The biggest one Keffler encountered was twenty-one feet from arm tip to arm

tip, making the arms about nine or ten feet long. But wrestlers came to the Puget Sound from all over the world, because there was nowhere else their foe were so large in shallow waters. Before the first world championship, Keffler recalled, the organizers became so worried that the divers wouldn't be able to find octopuses that they seeded the water with about nine octopuses, which promptly found holes to crawl into, but there were enough for the competition.

Keffler took part in the famous world championship octopus wrestling match in Tacoma, which was won by a tag team from Portland that won with an eighty-pound octopus. In April 1963, 111 divers took part in the World Octopus Wrestling Championships. A total of twenty-five giant Pacific octopuses were captured that day, ranging in weight from four to fifty-seven pounds.

A 1965 issue of *Time* magazine documented the growing popularity of octopus wrestling:

> *Such sports as octopus wrestling are coming increasingly into vogue, particularly in the Pacific Northwest, where the critters grow up to 90 lbs. and can be exceedingly tough customers. Although there are several accepted techniques for octopus wrestling, the really sporty way requires that the human diver go without artificial breathing apparatus.*

Gary Keffler was three-time World Octopus Wrestling Champion, *Photo by the author.*

Gary Keffler recalled that they primarily free dived, with no diving gear at all. "If you were perfectly still," he said, "you could hold your breath for four or five minutes." But moving, swimming, finding the octopus—usually quite reluctant to come out of its hiding place—had to be done with incredible speed. Later on, the snorkel was developed to aid divers, and they were allowed in the wrestling matches, but the divers lost points for using them.

As if that weren't enough, it turns out that octopuses are a lot smarter than we've given them credit for. They can learn to navigate and memorize their way through mazes. They can open jars, even though they can't possibly know why. And of course, the stories of octopuses escaping from their homes in zoos and aquariums through incredibly teeny holes are legendary.

It's easy to see why people would have been interested in the octopus wrestling. The only problem was that the octopuses weren't at all interested, so the wrestlers were forced to do a good deal of thrashing around in the water, making noises of faux struggle and prying the octopus's arms off of rocks if they tried to hang on. The octopuses just mostly bided their time and looked for an opportunity to get away.

The craze lasted about five years, and the wonder isn't that it ended so soon but that it became popular at all. In any case, the World Octopus Wrestling Championships were held in Tacoma in 1963, and that event was likely instrumental in ending the craze when spectators realized that there was no real athletic competition going on.

In 1964, humorist H. Allen Smith wrote in *True*, one of the premier men's magazines of the day, about a gentleman named O'Rourke whom Smith called the Father of Octopus Wrestling:

> *He knew full well, many years ago, what today's octopus wrestlers are just beginning to learn—that it is impossible for a man with two arms to apply a full nelson on an octopus; he knew full well the futility of trying for a crotch hold on an opponent with eight crotches.*
>
> *Now once the diver actually came in contact with the octopus, the rules were somewhat liquid, so to speak.*

Working in teams of two or three, divers would descend as far as sixty feet to the octopus's lair. The team would actually "wrestle" the octopus by painstakingly detaching the creature's suction cups and unwrapping its arms before slowly bringing the quarry to surface. Once on shore, the giant beasts were tossed on a scale for judging. After the championship competition, trophies were awarded and the octopuses were given to an aquarium or returned to the sea. Giant Pacific octopusus only live about five years.

On the surface, the World Octopus Wrestling Championship was a success; 5,000 people attended, and 111 divers from all over the world took part. Gary Keffler said the crowds were never that big, but the spirit was good.

The Washington State Library blog notes, "By the time the 1970s were over, the recreation of octopus wrestling had died out as Washingtonians became more ecologically aware."

Steve Wills added,

> *Although Ringo Starr supposedly thought up the song* Octopus's Garden *while in Sardinia in 1968, I'm betting the real story is that it first entered*

his brain in 1964, when the Beatles visited Seattle during the heyday of
octopus wrestling. Ringo probably first got the idea when the Fabs were
fishing in Puget Sound from their window at the Edgewater Hotel.

As Pacific Northwesterners began to understand more about the true nature of the octopus, attitudes changed. Thousands of people signed petitions to make the area where octopuses were taken into a protected park. Hood Canal, from which the wrestlers pulled record setting-giant octopuses, is now the Puget Sound's largest octopus preservation area.

Octopus hunting has now been banned on seven beaches, including Alki Beach. So the circle is completed. Strides have been made to keep the octopus population in Puget Sound healthy and thriving.

Keffler said that he agrees with the laws protecting octopuses, but he reflected that while he used to live below the water, he now spends his time above in a fishing boat. That his start below the water gave him a solid basis is reflected in the adventures he's managed to pack into a mere eighty-four years. He had a heart transplant that's lasted twenty-five years, twice as long as expected. His lungs, he says, are two times larger than normal—enhanced by all those years of diving. He and his partner Dale Dean worked to create a documentary called *Octopus, Octopus* with Jacques Cousteau.

He also was a stunt double for Lloyd Bridges, who played scuba diver Mike Nelson from 1958 to 1961 in the TV series *Sea Hunt*. For the series, Keffler would be filmed off the San Juan Islands doing stunts such as wrestling with an octopus.

He said he actually only met the star once or twice. They sent out the script saying what they wanted "Mike" to do, and Keffler would go out and do it. "You roll around, staging that you're fighting him," remembered Keffler. Then they'd mail the script and the filmed shots back to the studio.

The adventures continue. Gary Keffler spends time at Underwater Sports Seattle. Though the store now belongs to his children, it's a good place to look for him. A favorite occupation is keeping active in the family business by helping divers from ten years old to adults learn how to free dive, scuba dive, love and appreciate our sea.

While setting up for a radio interview at the store recently, Keffler clambered under desks and moved furniture with astonishing ease.

Does he miss diving? He shakes his head—but it turns out that he's not expressing a negative, but wonder that anyone could ask such a question. "Of course I miss it," he said. "Every day of my life." The octopuses were unavailable for comment.

GIG HARBOR: THE HOUSE THAT NELLIE BUILT

THE STORY THEY TOLD

Nellie the Pig, one of the performing Valentine Pigs, built the Gig Harbor home where she lived with Priscilla and Steve Valentine. Nellie was a natural-born star—a ham in every sense of the word. She had appeared on major TV shows from *Johnny Carson* to *Jay Leno* and even *My Home Town*. But what we found out when we returned to Gig Harbor was a big and sad surprise.

THE REST OF THE STORY

There's a natural heart-lifting moment when a traveler crosses the twin towers of the Narrows Bridge to Gig Harbor. And it's possible to imagine that the first explorers felt the same excitement. Historian Jim Kershner noted, "Explorers from the Wilkes Expedition discovered the harbor's well-hidden opening in 1841 and named it Gig Harbor because they had entered the bay in a small captain's gig." Then they were on their way again. Explorers never stay in one place.

The story they tell there is that in 1867, three fishermen rowed their fishing boat into the harbor for the night. In the morning, they looked

around, liked what they saw and decided they wanted to stay. Gig Harbor affects people that way. It's become a city of people who are doing exciting and unusual things. The seventeen net sheds that line the harbor are reminders of the town's beginning. My own favorite monument to the town's early settlers is the Fishermen's Memorial statue in Skansie Brothers Park. The fisherman himself is cast from bronze, but the net he hauls up is a real net made from knotted nylon like the ones that go out on the fishing boats, and like those nets, it needs to be replaced from time to time. The population of Gig Harbor has climbed from those three long-ago fishermen to a population of well over ten thousand, and the atmosphere is definitely of an affordable resort.

Gig Harbor is a wonderful combination of the whimsical and the real, and that brings us to the Valentine Performing Pigs. It was rare good luck to find them at home in Gig Harbor because this troupe of four-hooved stars traveled all over the world, wowing audiences wherever they went. The pigs, with their trainers and "parents," Steve and Priscilla Valentine, appeared on hundreds of TV shows.

Now, in the interest of full disclosure, I have to admit that I've never been a fan of pigs ever since I found out that they've been known to eat people if the circumstances are right. Most people can rise above this bit of information, but it's always seemed best to me to give them a wide berth just in case my encounter with a pig might happen to be the day when the circumstances were right.

Priscilla Valentine performed with her full troupe for more than twenty years. Audiences were fascinated to see what they could do, especially Nellie, the star. This beautiful white pig made several TV commercials, promoting financial preparedness by putting her money in—what else—a piggy bank and doing many other tricks, from twirling a baton like a drum majorette and occasionally raising the bar to carrying a pair of flaming batons.

Priscilla added that one of the hardest tricks is where the pig carries a flaming baton. In fact, Priscilla said, most fire marshals wouldn't allow them to do it. She observed, "Pigs are not natural athletes. They are natural eaters and sleepers. So the prize for carrying the flaming baton had to be something really good, like pizza."

For variety, Nellie would push a grocery cart and go shopping. Nellie and her companions were all Vietnamese pot-bellied pigs, very popular as pets, although as they grow, their upkeep can become quite expensive. But Nellie more than paid her own way.

Priscilla Valentine and Nellie, her beloved star. *Courtesy of Mike Landt.*

Visitors were blown over by Nellie's poise as she made phone calls, bowled, slam-dunked a basketball. How on earth can you teach a pig do all of these tricks? Nellie knew sixty. This is what Priscilla had to say about that:

> *I know of no way to make a pig do anything they don't want to do. They are very stubborn. So I have to make the pig think it was her idea. I will place the pig on the skateboard very gently. If she tolerates it, I will pay her* [with a treat]. *In that way, she soon figures out that she likes being on the skateboard.*

Children giggled as Nellie placed her allowance, an oversized coin, into a large piggy bank. Adults and children alike squealed with laughter when the pig retrieved a piece of mail from a large mailbox. The letter read, "Eat Beef," wrote Amanda Arthur in the *Daily Times-Call* after Nellie's performance at the Boulder County Fair.

Steve and Priscilla Valentine invited us into their home, built with the funds from those performances all over the world. They called it the House that Nellie Built. It turns out that these pigs are actually extremely clean animals. There was no odor, and I learned they like to keep themselves and their hooves very clean. The best thing about them is that they're so easy to housetrain. In fact, brand-new piglets can use the litter box the day they're born.

But a word of caution is in order from the Pig Placement Network. (Yes, there is a Pig Placement Network.) Vietnamese miniature pot-bellied pigs have become very popular as pets. They're very smart. And they are so adorable that people often feel that they should own one, so it's important to consider what goes with owning a pig and perhaps leave training to the experts.

A good deal of useful advice is given by the Pig Placement Network:

As you would do for any pet, make sure that household cleaning products, insecticides, medicines, lighter fluid and other toxins are out of reach. Remove plants that could harm your pig. Take potted indoor plants off the floor and don't leave handbags within reach. Pigs love lipstick and chewing gum! They are very clever with their snouts and particularly industrious when they smell food. If needed, secure your cabinets with childproof locks. Avoid feeding your pig out of the refrigerator. If your pig learns to open the fridge door, you might have to install a latch. Tape up computer, telephone and electrical wires where possible. We recommend that pigs be kept away from open swimming pools.

"Pigs have a reputation as dirty animals," Priscilla said. "They're not! They have no odor. They're sweet animals, and it's people who leave them in a muddy stall with piles of feces."

As written on the Valentine's Performing Pigs website:

Valentine's Performing Pigs *was a unique, fast-paced act that saw the dazzling performers, dance, jump in the air, play catch with the audiences, run up teeter totters, slam dunk basketballs, pop balloons, roll barrels and madly roar across the stage on scooter and skateboards. The audiences went HOG WILD.*

As Eric Lacitis wrote in the *Seattle Times*, "Human visitors at their home have to remove their shoes. The place is so tidy it looks like a model home."

Priscilla often commented that Nellie was the daughter she and Steve never had, and it turned out to be true. Sadly, Nellie died in 2012, and Steve and Priscilla soon followed her:

> *This website is in memory of Priscilla & Steve Valentine, who traveled all over performing shows with their potbellied pigs. Nellie was their first pig and the 'Star' of Valentine's Performing Pigs, but they traveled with many other pig performers throughout the years.*
>
> *Unfortunately, Nellie passed away in Feb. 2012 at the age of almost 20 years. Soon after, in March of 2012, Steve passed away from a long fight against pancreatic cancer. Then, just a month later, in April 2012, Priscilla passed away from complications of pneumonia.*

It's very compelling to believe that this couple really couldn't live without the "daughter" they loved so dearly.

On that visit to Nellie and her performing family, after Nellie showed her tricks, Priscilla invited us upstairs, and we saw Nellie's room. It was a bedroom any teenage girl would love, white with a filmy canopy over the bed. I mentioned that it was a little odd—or seemed to be—that Nellie slept upstairs in the "Princess" room. "Look," Priscilla answered, "Nellie built this house. She can sleep anywhere she wants."

Perhaps Winston Churchill said it best: "I am fond of pigs. Dogs look up to us. Cats look down on us. Pigs treat us as equals."

LAKEWOOD: BARBIE AND KEN AND KALVIN

THE STORY THEY TOLD

Listen, you ought to go over to Coffey's Frames in Lakewood, we heard over and over. She's got these dummies out in front, and they're telling a whole story. It's better than *Twin Peaks*.

THE REST OF THE STORY

Lakewood is a small city with a big past, proud of a timeline that stretches back to 1844. Lakewood's history extends from the advent of the Hudson's Bay Company through the visit of the Airship *Shenandoah* in 1924 to the fact that the first shopping mall west of the Mississippi was Lakewood's own Colonial Shopping Center. Lakewood became a city in 1997, and the scene was set for a story that can be counted on to bring a smile to every face. It's the ballad of Barbie and Ken.

They were just suddenly there one morning on the sidewalk in front of Coffey's Frames & Art on Gravelly Lake Drive in Lakewood (now the home of Bowman and Clark Furniture and Design). They didn't say anything to passersby and no one said anything to them. They were an attractive couple.

They sat there together, cool and collected and perfectly dressed. Yet in no time at all, they had worked their way into the hearts of Lakewood residents, and there they stayed for the better part of a decade. The perfect young couple weren't members of the nearby country club, and they couldn't be seen skating at the Lakewood Ice Arena. Instead, they were a pair of life-size mannequins that Judy Gunnell, co-owner of Coffey's Frames & Art, had put out in front of her store to attract attention. It worked. In no time at all, they had taken on a life of their own. Everybody loved them and, in an affectionate way, called them Ken and Barbie. No one said where the names came from, but it is important to point out that they were almost certainly named for the sixth-century Irish Saint Canice and third-century Greek Saint Barbara. They were not named after any modern-day trademarked toys. No. Lakewood is a pretty traditional town and chose traditional names.

Everyone followed the story of the young and stationary lovers with riveted attention. Residents would drive out of their way to wave and honk as they drove by, taking note of the costume of the day, carefully coordinated by Judy.

When the two became inevitably and officially engaged, Countrywide Mortgage assisted them in their search for the perfect home and provided them with new outfits befitting their station.

Their wedding was a huge community affair, covered by the press. The couple sported traditional garb, with Barbie wearing white and clutching a big bouquet of roses. The presiding official wore an Uncle Sam hat and red white and blue shirt in honor of the all-American couple.

In short order, the young couple bought a house, and the community continued to follow every detail as they settled in. The press reported that they found their dream home—in Lakewood, of course. Lynn Cory, the real estate agent, reported that they were a delight to work with—so receptive to her ideas and rarely contradicting her suggestions. And of course, the young couple were ideal romantics—never a cross word passed between them. Happiness abounded when the young couple gave birth—or whatever plastic mannequins give—to a lovely plastic baby.

So their ideal life continued. They had their jobs, as official greeters for the frame store, they had their dream home and baby and they had each other, but then, catastrophe struck. On a Thursday morning in February—no one is sure of the year, but somewhere around 1998—Barbie took up her appointed post in her folding chair, but Ken's chair was empty. It stayed empty all day. The worst was feared and justified. The police were called. Ken had been *abducted*. The *Lakewood Journal* wrote,

Judy Gunnell introduces Kalvin to Barbie. Barbie is comforted, can romance be far away? *Author's collection.*

"Poor Barbie was trying to come to grips with the fact that he might not come back." Barbie was desolate, of course. She had to send to Germany to ask her mother to travel to Lakewood to care for the baby so she could give her full attention to the search.

Ugly rumors began to circulate. A highly placed official at LeMay Refuse Company was quoted on condition of anonymity as saying that the remains of poor Ken had been found in the city dump—dismembered. "He just couldn't pull himself together," the official said, sadly. There was nothing left on Ken's chair except a hand-lettered sign, which read, "I was kidnapped. Find me!"

But in June 1999, I strolled down the street with beloved Mayor Bill Harrison. As we were taping our first *My Home Town* show in Lakewood, we were delighted to see that Ken was back. There he was, sitting with Barbie, just as usual. Judy Gunnell was quick to correct me. "No, this was not Ken. This is Ken's Cousin Kalvin from Canada, who has come to console Barbie," and it certainly looked as if he could. Momentarily charmed by

the alliteration, I was delighted to see that Barbie had apparently perked up and had eyes only for Kalvin, who looked much like Ken except for a floppy brown wig. Kalvin was missing one hand, but his pirate-style white shirt flowed over his arm, and all in all things were going well.

"That's what happens in Lakewood," Mayor Harrison proclaimed. "Romance is in the air." And it's true. Lakewood has always been a quirky place.

Lakewood occupies twenty-two square miles. The oldest frame home, the Boatman/Ainsworth residence, was built in 1858. The old Lakewood Colonial Shopping Center was the first shopping center built west of the Mississippi, in 1937. And to leave Lakewood, Mayor Harrison and I rode in an amphibious car that drove us to the shore of American Lake and right on across. It was from Bill Harrison that I first heard the famous Army Spirit Cry, "Hoo-ah!" I had just interviewed him in front of the beautiful new Lakewood City Hall when in a spirit of joy and enthusiasm, the beloved mayor, who had been the commander of nearby Fort Lewis, cried "Hoo-Ah." I was taken aback. "Hoo-Ah?" I inquired. "Yes," he said firmly. You don't argue with the general.

Lakewood residents point to more than their share of unique events. It was an exciting day for Lakewood in 1924 when the USS *Shenandoah* was tethered over the prairie. Co-founder of the Lakewood Historical Society Cy Happy recalled that Bill Boeing was in the crowd. It was just about a year before the *Shenandoah* crashed, killing most of its crew of twenty-five. The crash in 1925 put an end to the dreams of a fleet of these rigid helium-powered ships. Three ships were created, but all crashed within three years.

The Oakes Pavilion, built in 1923 as a ballroom with a ten-piece orchestra, on the north end of Lake Steilacoom, was a community icon. In 1936, it was purchased by Norton Clapp, developer of the Lakewood Colonial Center, to be used for private parties. In 1938, he turned it into the Lakewood Ice Arena, open to the public, because his wife loved ice skating. The Swiss chalet decor was charming and it became popular spot for Pierce County residents. Champion skaters trained there, the Lakewood Winter Club put on an annual *Ice Capers* show and avid fans watched ice hockey competition. The roof collapsed in 1982, and the pavilion was demolished. The Waters Edge Condo complex was built in the site.

The Lakewood Puppeteers were formed fifty years ago by Lakewood resident Jeanne Charleton. Jeanne and the Lakewood Puppeteers entertained more than 300,000 delighted children over the years. Audiences ranged from schools and libraries to the governor's mansion. Jeanne created most of

The USS *Shenandoah* brought dreams of a helium-powered air fleet to Lakewood in 1924. *Lakewood Historical Society.*

the puppets herself, with the aid of her puppeteers. At one time, it was estimated that the Lakewood Puppeteers consisted of more than three hundred puppets. Now, however, because of the fragile nature of the building materials, there are perhaps forty-five puppets left. These are hand and rod puppets, between twelve and thirty inches tall. A favorite rod puppet, Merlin the Magician, is five feet tall, and the beautiful Native American Great Spirit is about four feet tall.

Jeanne won many awards and introduced many local children to puppetry. At least one of those children is now a professional puppeteer. Jeanne Charleton is another Lakewood resident who will be long remembered and is now honored in a permanent collection at the Lakewood History Museum.

It was exciting, too, when crowds turned out for the opening of the Lakewood Racetrack–Tacoma Speedway in 1912, just one year after the Indianapolis Speedway. Becky Huber, past president of the Lakewood Historical Society, remembers its two-mile-long wooden track drew

The whole area turned out at the Lakewood Racetrack–Tacoma Speedway. *Courtesy of Pat Van Eaton and Van Eaton family.*

enthusiastic spectators in excess of thirty thousand and attracted the likes of Barney Oldfield and Eddie Rickenbacker. Unfortunately, because the track wore out and the winnings dwindled, it was shut down in 1922. It later became the Mueller-Harkins Airport in the 1930s, the Navy Advance Supply Depot in 1944–45 and now is the campus of the Clover Park Technical College. Students attending classes at the college are often surprised to learn that this very spot was once one of the premier sports attractions in the United States.

Of course, we can't forget beautiful Lakewold Gardens, opened to the public in 1989 and providing ten acres of gorgeous plants, including eight hundred rhododendrons, more than eight hundred species of trees and the iconic blue poppy. The main building in the gardens is the family home. It is so beautiful that it's easy to imagine that if *Downton Abbey* had been filmed in the United States, this would be the location. It's one of the few places in friendly, casual Lakewood where I really check my ensemble before arriving at the door. That was why it was a particular delight to get to spend time reminiscing with Cordy Wagner (George Corydon Wagner III) who was a teenager when his father bought the house. He regaled us with stories of adjustment to his new surroundings and showed us the marks in the closet where he had tried to kick his way out after his two sisters locked him into it. And then more marks where they tried to get out when he locked them in. He

remembered that as a teenager moving into the gorgeous Lakewold home and grounds with his parents and two sisters, he found himself assigned tasks around the house. He told us that his father decided that he needed to mow the lawn, and of course, the lawn covered ten acres. This would be his regular chore. Luckily, his assignment covered only the part of the lawn nearest the house. So he spent one hot afternoon mowing and mowing, and then, as teenaged boys will do, he had an inspiration. If he tethered the mower to the big beautiful tree in the yard, it would automatically do the work. He was a genius. So he tethered the mower and started it, and everything went well—for about three circles of the tree. But on the fourth circuit, the rope broke, and the mower sailed majestically into the water. As far as he knows, he told us, it's still there. There's no place like Lakewold, where the blue poppy grows. The grounds are fairy-tale perfect.

I just can't resist visualizing Barbie and Ken (or Kalvin) calling this beautiful place home. What the heck, there'd be plenty of room for Mama and the baby, too.

ENUMCLAW: THE PIE GODDESS HAD A SECRET

THE STORY THEY TELL

You can ask anybody in Enumclaw, Washington, and they'll tell you that you can find the Pie Goddess in her shop on the corner of Griffin and Railroad "katty-corner from the old train station." You can recognize the shop by the line of people standing out in front, wanting to be sure to capture a slice of what they'll tell you are the best pies in the world before the day's supply is gone. This is where the Pie Goddess bakes her pies, and they are incredibly delicious. One pie, lemon truffle, recently brought in $2,700 at auction to benefit the local hospital. People still travel from miles around to taste them as they did when we first met her twenty years ago. Everyone begs for the recipes. In particular, they want to know how to make that perfect crust.

THE REST OF THE STORY

Like all super heroes, Suzie Sidhu did not recognize her superpowers when she was growing up. In fact, she would have told you she didn't have any superpowers at all. Many years ago, Suzie's aunt asked her to fill in for her at the Rainbow Café while auntie enjoyed a trip to Reno with her friends in a

senior group. Now, what good niece could refuse such a request? Of course, Suzie said, "I thought, 'Are you crazy? I never made a pie in my life.'" But in Enumclaw, girls don't talk to their aunts that way, and after all, it was just help out at the café and make a few pies. Anybody could do that. So Suzie baked a few pies, and "they were OK. Not the best," she remembered, even after thirty-one years. Not something customers would rhapsodize about, and definitely not Goddess quality. But her aunt went away again and left Suzie to fill in for six weeks. Naturally, the pies got better. But Suzie still didn't know about her superpowers.

All that has changed. These desserts, legendary in the Northwest, aren't those flimsy little pies that fall apart when you lift them out of the disposable pie plate. Enumclaw is in timber country. Meat and potatoes is the gourmet preference for dinner, and the central square of the town features a huge bronze statue of two oxen straining to pull a log as big as they are. This is not a country where you'd serve a light salad and tapioca pudding. In Enumclaw, they're more the stick-to-your-ribs type of people—and stick to your heart sort of food.

Suzie traveled to Kissimmee, Florida, in 2008 to compete in American Pie Council's Crisco National Pie Championship. Family and friends

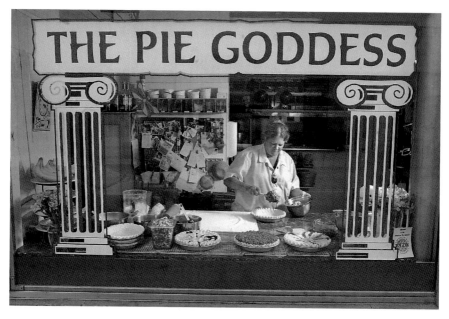

The Pie Goddess performs a miracle or two. *Courtesy of the* Tacoma News Tribune.

pitched in to get her there. The daughter of a friend offered a place to stay in Florida. Her mother bought airline tickets for a birthday gift, and Suzie raised money for the trip by raffling off a pie at one dollar a ticket. Of course, she won. A newcomer to the world of competition, both first- and second-prize ribbons in "The Other" category were hers. The first was for her signature Peanut Butterfinger Pie, the favorite of her son Luke, who was serving with the Marines in Iraq at the time. The other prizewinner was her Butterscotch Lush Pie. The Goddess had won her wings.

Suzie's been a popular guest on TV, crafting her pies like works of art. On a fundraiser for KCTS Cooks, on a local Seattle Public Broadcasting station, jaws dropped and whole households salivated as the Pie Goddess baked Rhubarb Custard pie, Frango Mocha Pie and the pie that won her the title of the Pie Goddess. This was a four-hour fund-raiser. Like any superhero, the Pie Goddess prefers to use her powers for good. At first, she was pleased when her pies earned hundreds of dollars for charity. Now one pie often brings thousands of dollars. Customers and friends beg for copies of the recipes, meriting the production of a cookbook, which will soon debut. But Susie Sidhu is a hometown product, and she is absolutely devoted to the idea of keeping her pies in her hometown. She likes to tell how a representative of a frozen food company approached her, planning to make the Pie Goddess a household name. "I mean, he wanted to take it to Seattle. And I said no." So the Pie Goddess will continue to brighten her corner of paradise.

It looks like the Peanut Butterfinger, don't you think? *Courtesy of the* Tacoma News Tribune.

Suzie's superpowers were revealed when, working at her Mom's Sweet Shoppe in Buckley, she was somewhat nonplussed when a customer stunned other diners by reacting to her piece of Butterscotch Lush Pie, causing stunned customers to echo the "I'll have what she's having" scene from *When Harry Met Sally*. "Ohh," the customer shrieked to Suzie, anointing her with the title that would define the rest of her life, "YOU" she pronounced, "Are THE PIE GODDESS!" She licked up the last bit of pie in her plate. "I'd leave my husband for you," she said, not going into how the logistics of this move would work—but

apparently, proximity to the fifty kinds of pies available at the Pie Goddess's fingertips would smooth the way.

If you talk to Suzie for long, the matter of what she calls her pie epiphany is bound to come up. This came when she went from thinking that a pie was just a pie to realizing that when you cut into a pie, it not only brings fragrance and flavor but also brings memories. She recalls cutting into a rhubarb pie and suddenly finding herself transported to her grandmother's kitchen, almost in joyful tears remembering the smells, even the rich soil in the backyard where the rhubarb grew. Suzie loves playing with ingredients, trying different pies, and each one of her customers has a favorite.

By now, the Pie Goddess estimates she has baked at least fifty thousand pies. On cold winter nights, it's a familiar sight to see folks lining up on the sidewalk to get one of the full-meal shepherd's pies, which nearly always sell out.

Suzie is very used to being asked for tips and hints. What is the secret to these wonderful pies? The Goddess is decisive: be sure that rolling pin and ingredients are ice-cold. Don't handle the crust too much. For everyone who has ever struggled and struggled only to find the crust getting tough enough to fill some of those potholes on the interstate, they are a mystery. Suzie isn't a bit shy about sharing. Crust should not be overhandled, but the secret isn't some obscure ingredient you won't be able to get for your kitchen. She uses Krusteaz. At first, it was downright shocking to hear that these heavenly pies had their start in a box mix. But to Suzie Sidhu, it's a no-brainer. "Why mess around and waste time when these crusts are as good as anyone could make from scratch?"

According to Coral Garnick in the *Puget Sound Business Journal*, Krusteaz was founded by pie bakers in a Seattle ladies bridge club in 1932. The company is now 94 percent owned by the grandson of founder John Heily and his sister, Timmie Holloman. Suzie just doesn't see the point in doing unnecessary work that takes a person away from the family and baking memories. She's happy for the credit to go to Krusteaz. She'll just keep baking and using her Super Pie Powers for good.

Puyallup: Set the Prairie Afire

The Story They Told

Puyallup is the home of the Puyallup Indian tribe and the Washington State Fair (once fondly referred to as the Puyallup). Right under the Red Gate at the Puyallup Fairgrounds is the Fred Oldfield Western Heritage Center, devoted to the century-long life and art career of cowboy Fred Oldfield. Fred loved his state and his family and his art, but mostly he loved being a cowboy. Fred died in 2017, before his many friends could celebrate the 100th birthday they were planning, but his memory is kept alive in the retelling of the stories Fred loved to tell. A favorite story of his was why cowboys out on the range set the prairie afire.

The Rest of the Story

Fred Oldfield died just three weeks before his ninety-ninth birthday. He was an artist and a cowboy. A real one. Not the sort you see on TV who stalks about the set in boots that have never lost their shine. Fred was born on the Yakima Indian Reservation in Alfalfa, Washington. During his early years, the family traveled around eastern Washington in a wagon with his nine siblings and hangers on moving from place to place looking for work. "We used to travel around in a wagon, looking for jobs, but to me it was

Cowboy artist Fred Oldfield at ninety-eight still teaching, painting and meeting with friends. Look at that smile! *Photo by the author.*

fun at fifteen or sixteen years old, running after rabbits, fishing wherever I wanted. Actually, I had to pick up cow chips for the fire."

There was never much doubt Fred would end up a cowboy. There was always some work available, but cowboying is hot and dirty and lonely except for the winters when it's cold and dirty and lonely and—did I say cold?

Fred Oldfield remembered that it would be so cold, those nights herding cattle, that it wasn't possible to catch even a minute's sleep in the saddle—there's no wood on the vast central Washington prairie. "Winter time we could get ten dollars a month for feeding cattle, for board and room; that wasn't bad money, but it was cold, dirty work." Riding in the cold, they'd beat their hands together and long for a breakfast of "coffee and a little hotcake." They wore heavy sheepskin coats, but no blankets, and when the cold got too severe, they'd set the prairie afire. Although there was no wood, in the searing winds, the tumbleweeds would roll across the prairie and pile up against the fences.

There was a real skill to the procedure. Quickly pack the tumbleweeds down on the ground, set fire to them, and when the prairie was burning nicely, you'd lay down on it quick as soon as the fire went down. With luck, the cowboy could get about two hours sleep before he had to do it all again, all night long.

Fred rode with his friends from the reservation for many years. He regularly rode the roundup until he was sixty-five. Cowboys are a lot like jet pilots. They may have to stop flying or riding, but they never stop being what they are. Fred always was a cowboy.

Fred Oldfield began painting at fifteen when he created a portrait of a bull thistle on the bunkhouse wall. For tenderfeet who maybe reading this, a bull thistle is considered a Class C noxious weed in Washington State with its purple flower, bulbous prickly body and sticker leaves. But Fred's picture sure looked like a bull thistle. He was so delighted with it that he painted a frame around it and then painted a nail by which to hang it.

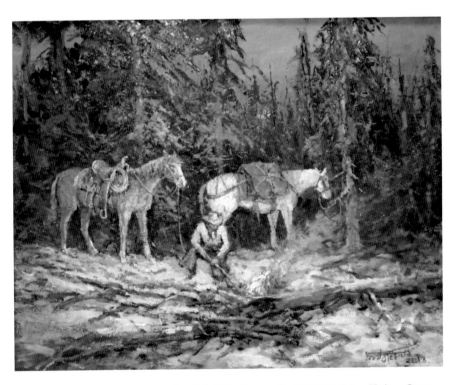

First Things First, oil on canvas, by Fred Oldfield. *Courtesy Fred Oldfield Western Heritage Center.*

Fred on Gretta. See you on down the trail, Fred. *Courtesy Fred Oldfield Western Heritage Center, photo by Molly Morrow.*

When his big brother came along, he said, "Fred, why did you paint that. It's nothing but an old bull thistle." But Fred said he was so thrilled that his brother Dick could tell what it was that he decided that very day to be an artist, and he never stopped learning about paint and colors until the day he died.

Fred's career began in earnest when he went up to Sitka, Alaska, before the start of World War II and found a place to stay in the establishment of a woman who in those days was called a "lady of questionable repute." Fred said he had no way of knowing about her shady reputation and had been taught to be polite to all ladies. It had been an old inn, and she said, "You go upstairs and if you can find a place to sleep, you can stay there."

"Twenty guys in that attic," Oldfield recalled, "and I was broke, and I started painting on linoleum squares. The lady—she'd take them out at night and go from bar to bar and sell them. In the morning, she'd call me and say, 'Come here kid.' She'd peel me off some money." Fred got five or maybe even ten dollars for those early paintings.

When Pearl Harbor came, young Oldfield felt he had to get into the fight. Of course, he had no money, but painting scenes on the back of leather jackets for flyers paid his way home in time to get into the war. Art school and illustration work came afterward, but he soon realized he wasn't just an illustrator. He had lived the life and history of the cowboy, and he needed to paint it.

Oldfield painted what he remembered: cattle and Native Americans, spectacular scenery and cattle ranchers. His paintings of Mount Rainier are iconic. He loved painting for the crowds at the fairs and at the Western Heritage Center, and a visitor on the way out could count on receiving a radiant smile and "See you on down the trail!"

At age ninety-eight, Fred was still painting and teaching and fishing, but he didn't get to fish as much as he wanted. He was always on the lookout for a way to escape from whatever he was doing and spend a couple of hours or a couple of days with a fishing pole.

One of the most popular projects that Fred never gave up were his quick draws—a reasonable project for a cowboy—but these are paintings produced in sixty minutes or less. Sometimes in as little as thirty minutes he would produce a complete painting. It was often a painting of a bucking bronco trying to twist his rider off into the dust.

Closest to Fred's heart were the classes he taught at the Western Heritage Center in Puyallup to students who came to learn about the history of the Old West and art from their beloved Cowboy Fred. The history of the West

Kautz Creek Pass, by Fred Oldfield, *Courtesy Fred Oldfield Western Heritage Center.*

comes to life in Fred Oldfield's paintings, from the sober hues of his work created after art school to the storytelling paintings of reservation days and the last narrative canvases when his palette exploded with an almost impressionist array of color. He never lost his sense of adventure and discovery—"I think I've got a new color," he'd say excitedly.

In Washington State, a person who reaches ninety-eight years has been a firsthand witness to this state's history. Fred Oldfield not only saw it, he also painted it. He was particularly partial to the stories of the Native Americans. His painting *Prisoners of Wounded Knee* shows a downtrodden, bedraggled people struggling gallantly through the snow and says it all. Oldfield remarked that it was his favorite painting. It can be seen at the Western Heritage Center in Puyallup along with a retrospective display of his work and life.

When Fred Oldfield celebrated his ninetieth birthday, Governor Christine Gregoire declared the day "Fred Oldfield Day in Washington," and that was exciting, but it wasn't the first time Fred Oldfield was honored that way. On March 18, 2003, the City of Puyallup, the City of

Federal Way and Pierce County celebrated Fred's eighty-fifth birthday and proclaimed it "Fred Oldfield Day." Gary Locke was governor of Washington State then, but the enthusiasm was the same when the entire Senate rose to give Fred a standing ovation for his contributions to the region and humanity.

A whole busload of Fred's friends went to Olympia for the exciting ceremony, and Fred, who always remembered that a cowboy must be polite, reverently removed his Stetson before entering the hallowed halls of the legislature. He carried the hat in front of him in two hands. When his friends were gathered in the balcony, above the legislators, they kept saying to one another, "Where's Fred?" "Which one is he?" From so far away, he looked small. Suddenly, one of the senators yelled (no other word for it), "Fred Oldfield, is that you?" Fred came forward hesitantly, still holding his hat before him. "Yes, ma'am," he said politely. "For Gawd's sake," she screamed, "Put your hat on. It doesn't look like you without it. Put your hat on, and don't ever take it off again."

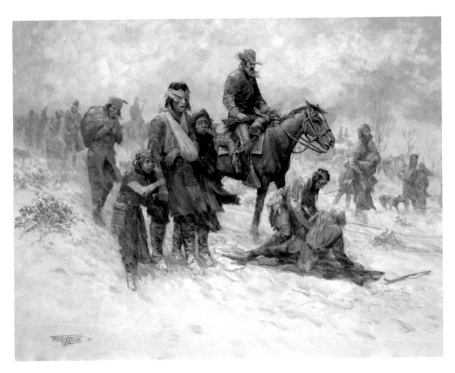

Prisoners of Wounded Knee, oil on canvas. *Courtesy Fred Oldfield Western Heritage Center.*

Humbly, he followed her instructions. As far as we know, he never took it off again. At least we never saw him without that Stetson.

History is in the eyes of those who see it lived and pass it on. Fred Oldfield's art leaves us an incomparable visual journal of what it was like to be there, setting the prairie on fire.

FOX ISLAND: THE LEGEND
OF THE CLAY BABIES

THE STORY THEY TELL

Generations of Puget Sound children seem to visualize Fox Island as sort of a Disneyland for foxes. Young faces fall when they learn the sad truth. There are no foxes on Fox Island. The island was named for an assistant doctor of the Wilkes Expedition, J.L. Fox, who apparently never set foot on the island that bears his name. Many great stories are told about this quirky 6.4-square-mile realm of creative and highly independent inhabitants. A favorite story is that Paul Bunyan got tired of the Great Lakes, tucked Babe under his arm, and came out west and dug Puget Sound single-handed. Now, that makes sense. There are no mountains in Bimidji, Minnesota, like Mount Rainier, and it's easy to see why Paul would be attracted to this beautiful country. There is a life-size statue of Paul (twenty-two feet tall) that seems to occupy Puyallup and Shelton simultaneously. Then there is the legend of the Clay Babies—natural Puget Sound sedimentary formations found nowhere else in the world.

THE REST OF THE STORY

Author and historian Don Edgers wrote that Fox Island first made it into the history books in 1856 when it served as a temporary Native American

reservation after the Indian War of 1856. The first settler to build a cabin on the island was John Swan, and from that beginning, the island boasts a population of about three thousand, with a very high proportion of creative people. Fox Island was the home of Washington's first woman governor, Dixy Lee Ray; cartoonist Gary Larson; and at least a dozen nationally known music groups—and of course, the Clay Babies.

Visitors to the west end of Fox Island often wonder why the waves wash pebbles up that are in the shape of birds, fish or other animals. It was George Miller, known as Mr. Fox Island, who shared the story of the Clay Babies. Many visitors hear about them for the first time at the Fox Island History Museum.

Like all good legends, this one starts with a beautiful maiden, the daughter of a chief called Batil Merman. She played in the sand at the west end of Fox Island many many years ago, and she would shape the mud into various forms. After awhile, she tired of her play and would wash her hands in the creek, making the waters muddy. In time, this place came to be known by the name of Tcekwila'lgo or "Muddy Water" and here the Clay Babies were born.

Daughter of Batil (legend of the Clay Babies). *Original art by Mark Ryan.*

When she grew to womanhood, many young Indian men from far and near sought to marry her, but she would not marry any of them. One evening, as she walked along the beach to her usual playground, a strange young man suddenly appeared. After some time, he came to speak with her. The next evening, he came again and the next, until the fourth night. Each morning, he departed as mysteriously as he came.

Interested in the young man, the young woman followed. On the fourth morning, she saw him reach the shore, and stepping into the water, he disappeared.

The maiden told her parents of this strange happening. As the parents talked and thought of this strange event, they became alarmed. They knew that this must be the son of the Old Man of the Sea. They knew that if they gave offense by refusing to allow their daughter to marry his son, then he might dry up the springs on the island until his son's suit should be granted. Their fears were not groundless, as events soon proved. The water in the springs disappeared, and as if by magic, grass became brown and the crops died. As soon as the parents gave their consent for their daughter to marry, the springs returned to normal.

At last, one day, the young man came to claim his wife. Taking her hand, they stepped into the sea and disappeared beneath the surface. Three times the daughter returned to visit her parents. On the fourth visit, although they loved her dearly, there was no denying the changes that were happening to her. There was kelp growing on her face. She was assuming the nature of a sea creature.

The parents were sad to see her so changed and told her it would be better if she did not return again. She left them forever to live with her husband underwater.

But still, the legend goes, when she grows lonely, she returns to her old playground and makes the odd shapes that visitors find in the clay and sand—it is said that she hopes that her parents will find the shapes and know she loves them still—and these are the Clay Babies.

Find this story a little hard to believe? Don't take our word for it. Just look out into the sound where a floating buoy marks the spot, midway between Fox Island and the town of Steilacoom, under which the young couple built their home. That's what George Miller said.

NOTE FROM FOX ISLAND HISTORICAL MUSEUM

Clay Babies are really concretions, natural sedimentary stone structures formed in soft sediments such as sands, clays and shales. They begin by minerals accumulating in the pores of a sediment around a nucleus or center, which could be of organic or inorganic matter. The binding constituents are silica (quartz), calcite (calcium carbonate) and/or iron oxide. They erode out of softer materials.

The result is quite unique. If you can't find one on the shore, stop in at the Fox Island History Museum, where docents will be glad to show their collection of Clay Babies.

Our TV crew taped three shows on Fox Island, and after each show, George Miller sent a long handwritten letter of all the things that could be improved upon for the next visit. George loved Fox Island, and everyone loved George. He was very particular that his home place be shown in its best light.

The Fox Island History Museum is a very special place. It says a lot about the character and personality of Fox Island when you notice that a past historical society bulletin once offered free puppies with every membership (subject to availability).

The same bulletin includes a quote from Governor Dixie Lee Ray: "A nuclear power plant is infinitely safer than eating, because 300 people choke to death on food every year."

A familiar landmark on a visit to the museum is the small brown cabin next door. According to History Museum president Karen Kretschmer,

> *The cabin was used by Lila Acheson, whose family lived on Fox Island in the early part of the 1900s. She moved away and married a Mr. Wallace, and they just happened to start up the popular* Reader's Digest.
>
> *The squirrels that visit the Acheson Cabin have tried to make it their home. They bring in cones, rest in the cradle, and spread yarn around the room. They've also learned a few things about adaptation. Generations of squirrels have inhabited our community and many of us have squirrels and/or stories that we'd be happy to share.*

Karen also pointed out that the Fox Island History Museum has many Native American artifacts and the largest pulley block collection in the state, which is something of a mystery to those who didn't realize that pulley blocks needed collecting.

The Clay Babies of Fox Island. *Courtesy of Fox Island Historical Society, photo by Karen Kretschmer.*

The Little Brown Cabin at Fox Island Historical Museum. *Photo by Karen Kretschmer.*

One of the popular and mysterious exhibits at the Fox Island History museum is the Lady in the Bathtub. This is a lady reclining in a bubble bath. The bubbles are made of plastic, but so is the lady.

Karen Kertschner, concludes her tour this way:

> *Come on in and meet the family. Dixie is here and Lila and the Lady in the Bathtub. The kitchen is clean and the rooms have been tidied. We're waiting to share stories with all who visit. And yes, you'll probably find a little dust in the corners, just like home.*

It would be hard to find someone who doesn't love the Fox Island History Museum and the clay babies. I feel a special attachment because the legend involves a mother who misunderstands her daughter. I do have serious doubts about that mother's behavior. After all, what mother would cast her daughter aside because she was growing seaweed on her face? A seasoned mother would just nag her about it and offer good advice about skin cream.

FIFE: RETURN FROM MINIDOKA

THE STORY THEY TOLD

After touring the Fife History Museum, I asked the question that was repeated in every town we visited. "What do you want people to know about your hometown?"

"It's a very warm, friendly town," came the reply.

Well, everyone says that. "Tell me one thing," I said, "that shows your warmth and neighborliness."

"Did you know that during the Japanese Internment in World War II, the people of Fife not only stood behind our absent neighbors, even keeping their property in trust and maintained, but also had the earnings from the crops ready for those neighbors when they came home?"

"No," I said, "I didn't know. I didn't know."

THE REST OF THE STORY

Fife, population approximately ten thousand, may have been named for William Fife, a prominent Tacoma lawyer. Maybe not. Nobody seems quite sure about that, and the fact is that Fife isn't a place that comes to mind first when you're talking about picturesque Washington towns. I didn't know much about Fife except that it was a farming community growing wonderful

produce on what was said to be the richest farmland in the whole world. The soil that was buried beneath the I-5 freeway running through Fife is said to have been richer than the soil in the Tigris-Euphrates valley. It can never be reclaimed because of the development. To the outsider, Fife might look like a wide spot in the road, a good spot to stop on the way to Seattle for a snack, gas or other necessary tasks.

This story of wartime solidarity and determination is unique and totally unexpected. It is also true. Residents of Fife who lived the story shared it with us.

One thing that has always been unique about Fife is its large, stable Japanese population. The Japanese farmers came to America early and worked hard, and by 1920, their farms were supplying half the milk in King and Pierce Counties. They also supplied 75 percent of the fresh vegetables, as those hardworking families made every inch of their small farms (five to fifteen acres) yield produce. So by the start of World War II, the Japanese were well established. They had already overcome many seemingly insurmountable difficulties and had proved themselves valuable and welcome neighbors. Nothing could have prepared them for the events to come.

In 1921, the Washington State Legislature passed the Alien Land Law and effectively stacked the deck against these hardworking people. As historian David Takami wrote in his essay on Japanese farming, it was this law that was responsible for restricting property ownership.

Washington's 1889 constitution, in fact, banned the sale of land to "aliens ineligible for citizenship," and only Asians were ineligible to be naturalized citizens. The new law extended the restrictions to cover leasing or renting land and renewing old leases.

Takami continued, "Issei [first-generation farmers] got around the law by making arrangements with white farmers, who would technically own the land and employ the Japanese as 'managers'—of their own farms. Issei also bought land in the names of their children." So now the stage was set for one of the most unjust chapters in American history—the internment of these incredibly loyal Japanese Americans.

Elsie Yotsuuye Taniguchi and her family were among the Fife residents interned first at Camp Harmony and then Minidoka. Elsie recalled that they were constantly under guard, never trusted. Elsie is scornful about the falseness of even the name. "Harmony!" she scoffed, "There was no harmony there!"

"In school, the first thing to do was to pledge allegiance to the flag. Actually, this was the only flag we knew. Ironically, as kids we always ended

with the words 'liberty and justice for all,' when in fact we had no liberty, no justice," she said.

Elsie's mother, Kazue Uchida Yotsuuye, graduated as valedictorian of her class at Fife High School in 1932. She graduated from Knapps Business College in Tacoma and married Toju "Tom" Yotsuuye of Brookville Gardens in Fife, Washington, and she was a member of the Puyallup Valley Japanese American Citizens League and Whitney United Methodist Church. Hard to imagine anyone more American than that.

By 1940, a chamber of commerce blurb described "Fife...at a valley crossroads in the midst of a thickly settled berry growing and truck-gardening district is represented by a string of markets, taverns, shops, and a large, balloon-roofed dance hall along the highway." The 1940 population was 135.

The order that changed life forever for 120,000 innocent incarcerees of Japanese ancestry from the West Coast and Alaska and Hawaii was enacted on February 19, 1942, with the signing of Executive Order 9066.

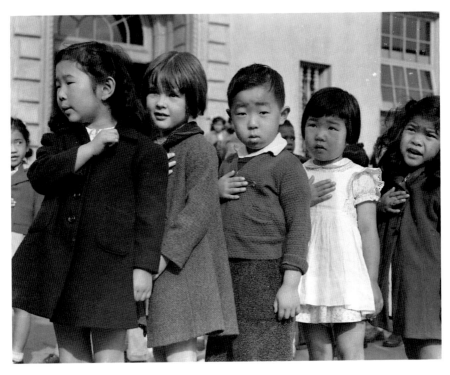

Schoolchildren reciting the Pledge of Allegiance. *Courtesy of the National Archives and Records Administration.*

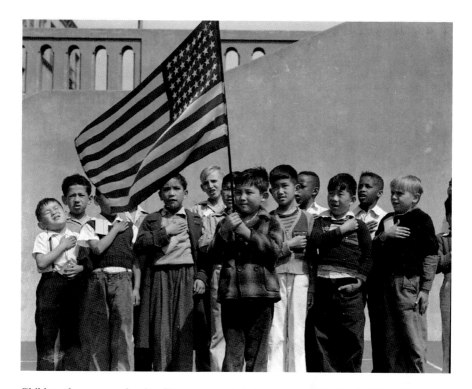

Children demonstrate loyalty. The men who left the camps to fight for the United States with the 442nd were part of the most decorated unit in history. *Courtesy of the National Archives and Records Administration.*

But the winter dragged on, and it was May when the dreaded day finally came and families received the military notification that they must vacate their homes, their land, everything they had thought was theirs. In *Nisei Daughter, Life in Camp Harmony*, Monica Itoye Sone wrote, "Up to that moment, we had hoped against hope that something or someone would intervene for us."

The Japanese families from Fife and the Puget Sound area were first taken to what was called Camp Harmony at the Puyallup Fairgrounds. The media made much of the cheerful spirits and almost party-like atmosphere they reported in the evacuees. The name Camp Harmony was a media creation, part of a campaign by the U.S. War Relocation Authority (WRA) to show that really, the wholesale uprooting of these communities was causing no problem and that ordinary citizens, preoccupied with the war effort, need give it no thought. In Seattle and other places, the Japanese American Citizens League actually assisted the military with the move, but Elsie explained that

this was to protect and expedite the ordeal for the people involved. This was to be a temporary location before more permanent centers could be opened, farther away from the coast. More than 7,500 people were living in Camp Harmony by the first of June; 1,200 had come from the Pierce County, Tacoma-Puyallup area. Everywhere, Japanese homes and communities were boarded up. It is heartbreaking to read the restrictions placed upon the internees. Evacuees could use their own cars, with the understanding that the vehicles would be impounded when they arrived at their destination. Robert Mizukami, who became the second mayor of Fife after it was incorporated in 1957, recalled being dropped off the train in the middle of nowhere. "It was all sand and sagebrush," he said, but tour buses from Sun Valley Resort had been sent to take the weary travelers to their place of imprisonment. Mizukami went on to become one of the many Japanese who fought loyally for their country in the famed 442nd Army Regimental Combat Team. Per the *Densho Encyclopedia*, "The 442nd became the most decorated unit of its size in U.S. military history. In less than two years of combat, the unit earned more than 18,000 awards, including 9,486 Purple Hearts, 4,000 Bronze Stars and 21 Medals of Honor." President Harrry Truman said, in presenting a special presidential award, on July 15, 1946, "You fought the enemy abroad and prejudice at home and you won."

The 442nd, whose motto was "Go for Broke," was made up almost entirely of men who left their families in the camps to fight valiantly and prove their loyalty to their country.

The departure for the Puyallup Camp was like the start of an excursion party, said the *Seattle Times*, but the *Times* also headlined that story, "City's Jap Evacuees start 'Housekeeping' in Puyallup." No awards for sensitivity will be given. Their homes were now declared a restricted military zone. Naturally, there was no choice and no debate. Many people had to dispose of property and pets quickly. Few Japanese would return to their lands.

Few would have anything to go back to.

Elsie Yotsuuye remembers being a five-year-old attending Fife Elementary School, no different than any of her classmates, as nearly as she could tell:

I was taken out of school to be incarcerated with my family. We were given seventy-two hours to get ready, and we could only bring what we could carry. My grandparents, my parents, my younger brother and I were bused to the Puyallup Assembly Center in Puyallup, Washington, which was fenced with barbed wire and armed guards kept watch over us twenty-four hours a day. Our barracks were about twenty feet by twenty feet, and one

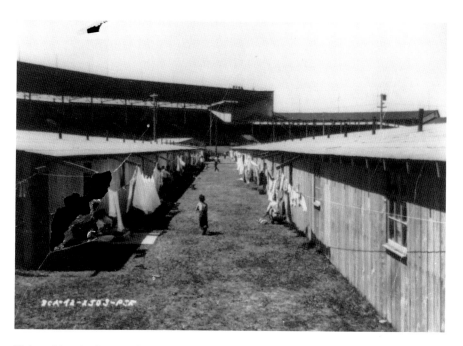

Elsie and her family were first interned at the Puyallup Fairgrounds, known as Camp Harmony. *Courtesy of Densho, the National Archives and Records Administration.*

light bulb lit the room with four cots and a potbellied stove. Our mattresses were stuffed with hay, and we could still smell the remains of the cattle, which used to be there. After three months in Camp Harmony in Puyallup, we were moved to Minidoka, Idaho, by train. The Minidoka camp was in a lonely country filled with sagebrush and lava rocks. Our family lived in Block 12, Barrack 6, Room D. Unfortunately, my Grandfather Yotsuuye was taken away from our family as a prisoner of war, along with other Japanese leaders of our community. He was taken to Montana to live in isolation without knowing what was happening to his family. He lived away from all of us for three years and eventually was able to return to family as we were being released in 1945.

The incarceration took a terrible toll on the whole family. Elsie's grandfather passed away from a broken heart and spirit, and her grandmother suffered a major paralyzing stroke.

Meanwhile, in Fife, all went on as usual. It was still a small farming town joining in the war effort. Its landmarks were the Poodle Dog restaurant and

Elsie Yotsuuye Taniguchi and her mother, Kazue Uchida Yotsuuye. *Courtesy of Elsie Yotsuuye Taniguchi.*

Century Ballroom, where dancers swayed to the music of the top swing bands of the day, from Tommy Dorsey to Glenn Miller. There were two shifts of dances. The second started at 1:30 a.m. for the convenience of defense workers.

But what there also was a rising sense of outrage at what had happened to their Japanese neighbors.

Joseph Conrad of the Seattle Office of the American Friends Service Committee wrote in May 11, 1942:

> *Think what these people had been doing the past week, standing in line, first to register, then for physical exams. The last frantic arrangements, selling, storing, dispensing with precious possessions, leaving pets and gardens behind, then the last night, most of them up until 4 and 5 am packing, getting everything ready for the early morning departure, everything neatly labeled and properly boxed. Then for a few hours sleep on the hard floors in a home, empty of furniture, no beds or mattresses; those sold or stored. Then at 6 or so up and get the children ready, dress in your best clothes, come down in the pouring rain of a cold, drear day, stand in line and mill around in the confusion of departure for an hour and a half.*

One unbearably touching feature that Elsie shared were the yearbooks put together at Minidoka to show how life continued. People were born and died, they married, they graduated from high school—all the while behind the barriers that were the camp walls. People in the camps had no way of knowing what was going on at their homes. They wondered if they could ever return home again. Many never did. There was nothing to go back to except a sense of disillusionment.

As we talked about how difficult it was to pack up a family and be ready to leave in just seventy-two hours, Elsie recalled that she had just gotten a new little white kitten. She wanted so badly to take it along, but no pets were allowed. She cried and cried, she remembered, and her mother went out and bought all sorts of kitty food in the hope that someone would feed the little creature. They didn't know how long they'd be gone. Maybe only a few days. No one imagined three years. "But what happened to the kitten?" I asked. Elsie looked at me as if I were not quite bright. "Well, it died, I guess," she said.

Now at last comes the heartwarming part of this very personal history. When Elsie's family returned to Fife, they found that their Brookville Gardens Farm was being held for them by the efforts of community members and

Elsie Yotsuuye Taniguchi with family. *Courtesy of Elsie Yotsuuye Tanaguchi.*

neighbors. The land was being worked and the money for crops held for them. This was repeated on several farms in the Fife area. Unfortunately, it was a very difficult thing to do because of the Alien Land Act, which had so restricted what could be done. Families who had been "managers" or tenant farmers didn't find the same welcome. An Auburn, Washington matriarch, Kisa Iseri, told me on camera how bitter her brother, who had fought in the 442nd, felt when he returned home and found blowing dust and nothing

more. He left the area and never returned. In Fife, the residents did all they could, continuing to forge a strong and productive relationship. Today there is still a very strong representation of Japanese Americans, reflecting the kindness and respect the community has always held for all of its residents. Elsie reflected in a recent Facebook entry that after these U.S. citizens spent three years behind barbed wire, only 6 percent of Fife's Japanese returned to Fife. However, this was the HIGHEST percentage of folks returning to their previous town in the state.

In a promising end to this story, a portion of Brookville Gardens has been donated back to Fife by the Yotsuuye family for a natural community park and sports complex. At this writing, the park has opened to the public, with trails, playing fields and a children's playground in place, and work has begun on the pedestrian bridge to provide easy access to the park. Brookville Gardens Park provides a hopeful end to this story of community support and love. "Brookville Gardens is going to be gorgeous!" someone wrote on Facebook.

It was easy to "like" that page.

FINAL WORD: THE HEART LADY OF FOX ISLAND

*L*enore Clem lived on Fox Island with her daughter and son-in-law. As a lady of advancing years, she was no longer able to take part in the many projects that had occupied her for most of her life, but she was still very handy with a needle. So, in 1991, when she received a request from Mary Bridge Hospital in Tacoma to create something to be used as an award for children who attended a camp for kids who had cancer, Lenore thought about it, and then she created soft stuffed hearts, just the right size to hold in a small hand. The kids loved them. They were plump and squeezy. Soon the hospital asked for hearts to go in the incubators in the preemie units because they were cuddly but too small to be dangerous. Soon Lenore was sewing a lot of hearts and working hard to fulfill requests. Lenore's twin sister, Louise King, joined her, and at the time I met Lenore, they had sent eighty thousand hearts around the world. While I was there working on the interview, we received a call from a doctor in California. He had a patient suffering depression after the loss of a baby. He thought this hand-sewn gift of love might help. Hearts were sent right away. More and more requests came in.

Lenore and her sister were eighty-six when I met them. Lenore had come to look at her sewing project as her employment. She'd get up and have breakfast, and then she'd go to work. Very little could get in the way of her work—and she worked fast. I sat with her for a while, and she was still pretty good with a needle. She could make one of the plump little stuffed hearts in four minutes. I could very nearly get my needle threaded in that length of

Hearts created by the Heart Lady of Fox Island, Lenore Clem. *Photo by the author.*

time. Lenore's daughter, Georgia, wrote about Lenore and Louise: "They got requests for hearts from everyone, from nurses to flood victims. Fabric was donated, collected, scavenged and the work continued."

Lenore passed away in 2014 at ninety-two, and it was estimated that she was responsible for sending more than 100,000 hearts around the world. Here was a woman who could have said, "Now that I'm old, I can't do much." Instead, she did what she could and enlisted her sister to join her. In a time when the lessons of history are often forgotten and kindness is often mistaken for weakness, it's important to remember that it's not necessary to do something big. It's only necessary to do what you can.

Georgia wrote, "What a wonderful world it would be if everyone had a feelie heart in their pocket to remind them that they are in someone's heart." It would be wonderful to remember that, and it would be good to remember that we are who we are because of those who went before.

Bibliography

Anderson, Steve A., ed. *Fort Nisqually Indian Accounts Book Commencing September 1849, Ending January 1851*. Newport, NC: Steve A. Anderson, 2010.

Andrews, Mildred. "Woman Suffrage Crusade, 1848–1920." HistoryLink, February 26, 2004, http://historylink.org/File/5662.

Bagley, Clarence B., ed. *Journal of Occurences at Nisqually House, 1833*. Compiled by Clarence B. Bagley.

Beckley, Brian. "Bonney Lake Uses Modern Technology to Map the Route of Settlers through the City." *Bonney Lake–Sumner Courier-Herald*, January 3, 2011.

Bidwell, John. *First Three Wagon Trains*. Portland, OR: Binfords & Mort, 1961.

Carpenter, Cecelia Svinth. *Fort Nisqually: A Documented History of Indian and British Interaction*. Tacoma, WA: Tahoma Research Service, 1986.

Colyer, Ralph R. *Fircrest*. Charleston, SC: Arcadia Publishing, 2015.

Crooks, Drew. *Past Reflections: Essays on the Hudson's Bay Company in the Southern Puget Sound Region*. Tacoma, WA: Fort Nisqually Foundation, 2001.

Curtis, Joan, Alice Watson and Betty Bradley. *The Town on the Sound: Stories of Steilacoom*. Steilacoom, WA: Steilacoom Historical Museum, 1988.

Densho Encyclopedia. https://encyclopedia.densho.org.

DeVoe, Edna Smith. *Washington Women's Cookbook*. Seattle: Washington Equal Suffrage Association, 1909.

Egan, Ray. "Rossi, Father Louis (1817–1871." HistoryLink, March 6, 2009. http://historylink.org/File/8498.

Handeland, Arne. *University Place.* Charleston, SC: Arcadia Publishing, 2013.

Harnel, Marie. "The Octopus that Almost Ate Seattle." *New York Times,* October 16, 2013.

Jacobsen, Winona, and the Greater Bonney Lake Historical Society. *Bonney Lake's Plateau.* Charleston, SC: Arcadia Publishing, 2011.

Kendle, Kristine. "What Makes University Place Worth Living In?" *Suburban Times,* September 26, 2017.

Laeson, Dennis. *Hop King: Ezra Meeker's Boom Years.* Pullman: Washington State University Library, 2016.

Lavender, David. *The Fist in The Wilderness.* Garden City, NY: Doubleday, 1964.

Merryman, Kathleen. "Ghost in the E.R. Rogers Mansion, 1991." *Tacoma News Tribune,* n.d.

Morgan, Murray. *Puget's Sound, A Narrative of Early Tacoma and the Southern Sound.* Seattle: University of Washington Press, 1981.

Munyan, May G. *Du Pont: The Story of a Company Town.* Puyallup, WA: Valley Press, 1971.

Newnham, Blaine, Tom J. Cade and Robert Trent Jones. *America's St. Andrews: Linking Golf from Its Past to Its Future, Publicly-Owned Chambers Bay Is the Dream Realized.* Tacoma, WA: Green Cloud Media, 2014.

Osness, Richard D. *Of Lions and Dreams, Of Men and Realities: An Illustrated History of Fircrest, Washington.* Tacoma, WA: Western Media Print. and Publications, 1976.

Rhind, Bill. *Curator's Journal of the Fort Nisqually Living History Museum.* Tacoma, WA: Fort Nisqually Living History Museum, n.d.

Ross-Nazzal, Jennifer M. *Winning the West for Women: The Life of Suffragist Emma Devoe Smith.* Seattle: University of Washington Press, 2011.

Sensel, Jean. *Spanaway.* Charleston, SC: Arcadia Publishing, 2014.

Sone, Monica Itoi. *Nisei Daughter: Life in Camp Harmony.* Seattle: University of Washington Press, 2014.

Stefoff. Rebecca, *The Oregon Trail in American History.* Berkeley Heights, NJ: Enslow Publishing, 1997.

Stevenson, Shanna. *Women's Votes, Women's Voices: The Campaign for Equal Rights in Washington.* Tacoma: Washington State Historical Society, 2009.

Surina, Blake. "In Tracing the Historical Connection between University Place and Fircrest." *Suburban Times,* February 4, 2014.

Tan, Sheryll. "How to Make the Most of a Visit to Chambers Bay: 7 Things Not to Miss." Windermere Real Estate, August 3, 2017. http://www.windermerepc.com/blog/entry/how-to-make-the-most-of-a-visit-to-chambers-bay-7-things-not-to-miss.

Wilhelm, Dorothy. *My Home Town*. "Buckley" Executive producer, Ed Hauge. AT&T, February 2001.

———. *My Home Town*. "Buckley" Executive producer, Ed Hauge. Comcast, December 2003.

———. *My Home Town* "Lakewood, DuPont, Tumwater, Ennumclaw, Fox Island, Gig Harbor." n.d.

Wilkins, Steve. "'Mo-Jo' Bigfoot in Bonney Lake: Real or Myth?" *WSRT Journal*, July 7, 2009.

Willis, Steve. "Free Drinks on the House, Courtesy of a Train Wreck." Between the Lines, Washington State Library Blog, March 1, 2013.

ABOUT THE AUTHOR

Photo by Bonnie King.

*T*hree decades ago, Dorothy Wilhelm was a widow with six children and a bleak outlook. She had less than a year toward her college degree, no work history and, as far as she knew, no employable skills. She could not even drive her car on the freeway.

Today, she still has six children, but everything else has changed. She is a columnist, humorist, speaker and broadcaster. She has spoken to audiences from Bangkok to Nashville. She spent ten years as creativity expert for KIRO radio and TV in Seattle and hosted Beacon Award–winning *My Home Town* on Comcast TV for another decade. Dorothy now does an internet radio broadcast, *Swimming Upstream*, on the SOB Radio network. (That stands for Spunky Old Broads. All the hosts are women over fifty.)

She does tai chi three times a week, including sword form—and she drives anywhere she wants. Contact Dorothy or listen to the radio show at her website, www.itsnevertoolate.com.